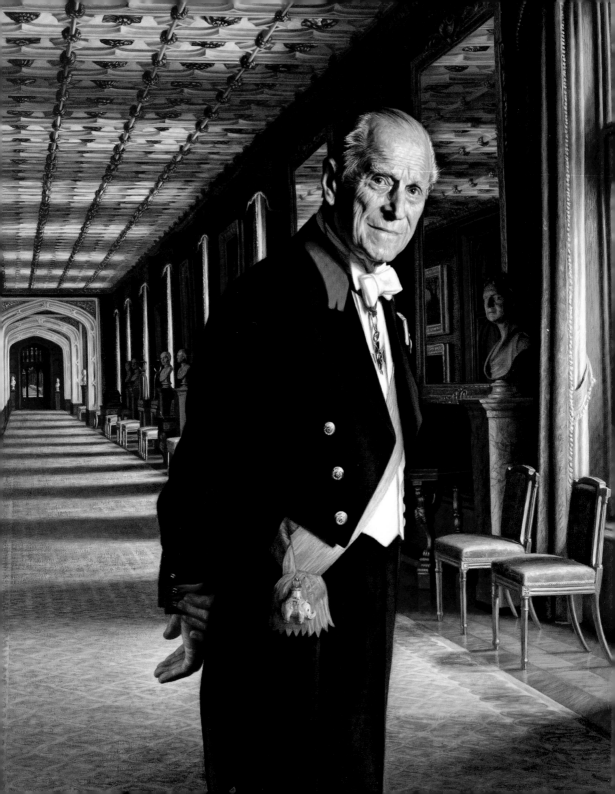

PRINCE PHILIP

1921–2021

A CELEBRATION

DEBORAH CLARKE & SALLY GOODSIR

ROYAL COLLECTION TRUST

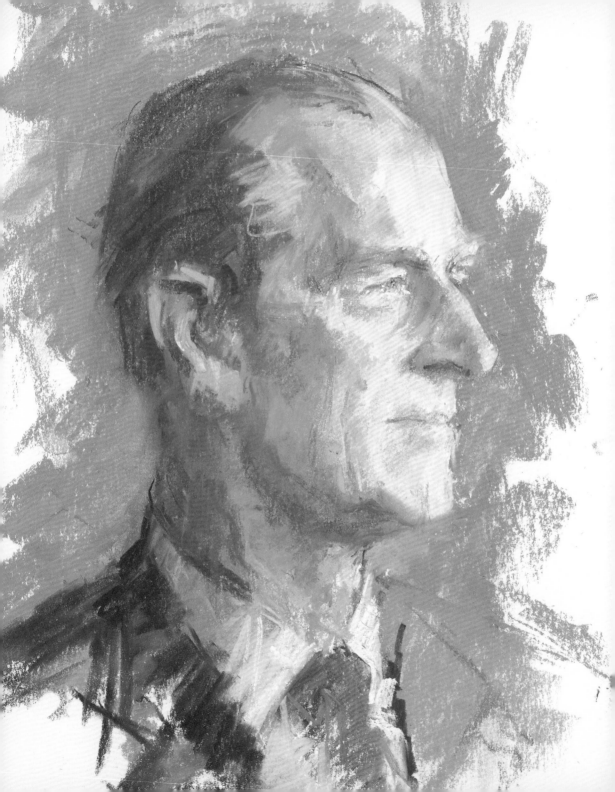

CONTENTS

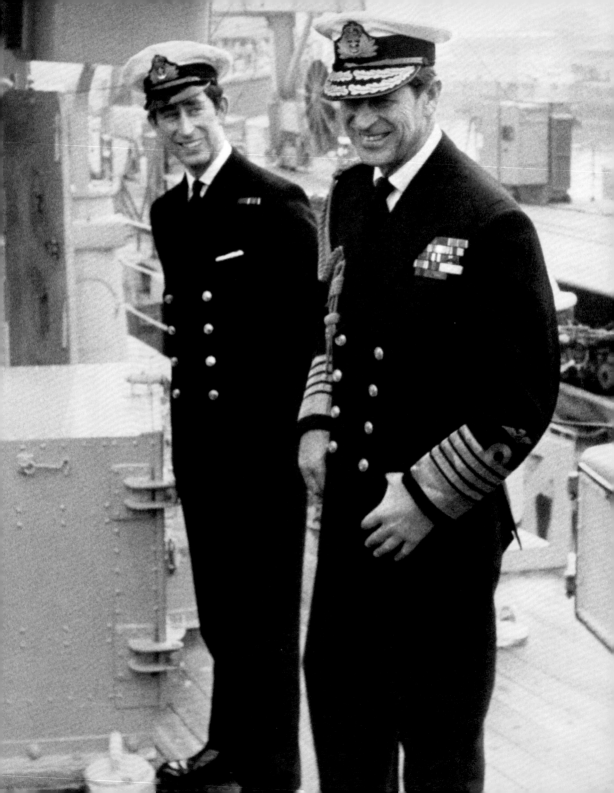

CLARENCE HOUSE

After the announcement of the death of my father, His Royal Highness The Prince Philip, Duke of Edinburgh, on 9th April 2021, heartfelt tributes poured in from every corner of the world, honouring a man who had dedicated his long life to public service.

He will be remembered for a distinguished naval career, and for serving with distinction in the Second World War; for his very real and committed engagement with the many causes and charities of which he was patron; for his concern for wildlife and the future of the planet and for his empowering of young people from all communities and those with disabilities, to build life skills and resilience through the Duke of Edinburgh's Award. Perhaps, most of all, his legacy consists in supporting The Queen and the institution of monarchy through many years of radical social and technological change.

In The Queen's own words, spoken at the banquet to mark their Golden Wedding anniversary in 1997: "He has, quite simply, been my strength and stay all these years and I, and his whole family, and this and many other countries, owe him a debt greater than he would ever claim, or we shall ever know."

Queen Victoria *m.* Prince Albert
(1819–1901) (1819–61)

Christian IX, King of Denmark
(1818–1906)

King Edward VII *m.* Alexandra
(1841–1910) (1844–1925)

George I, King of Greece *m.* Olga Constantinovna
(1845–1913) of Russia (1851–1926)

King George V *m.* Mary of Teck
(1865–1936) (1867–1953)

Sophie of Prussia *m.* Constantine I, King of Greece
(1870–1932) (1863–1923)

King George VI *m.* Elizabeth Bowes-Lyon
(1895–1952) (1900–2002)

Paul, King of Greece
(1901–64)

Margaret
(1930–2002)

Andrew *m.* Alice
(1882–1944) (1885–1969)

Margarita Theodora Sophie
(1905–81) (1906–69) (1914–2001)

Queen Elizabeth II *m.* **Prince Philip**
(b. 1926) (1921–2021)

Charles (b. 1948)
m. (1) Diana Spencer (div. 1996)
m. (2) Camilla Parker Bowles

Anne (b. 1950)
m. (1) Mark Phillips
m. (2) Timothy Laurence

William (b. 1982)
m. Catherine Middleton

Harry (b. 1984)
m. Meghan Markle

Peter (b. 1977)
m. Autumn Kelly

George (b. 2013) Charlotte (b. 2015) Louis (b. 2018) Archie (b. 2019)

Savannah (b. 2010) Isla (b. 2012)

FAMILY TREE

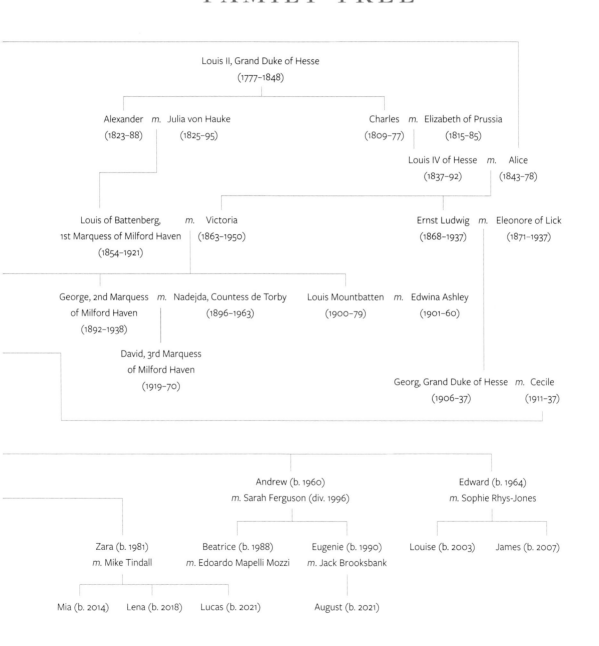

Louis II, Grand Duke of Hesse
(1777–1848)

Alexander *m.* Julia von Hauke
(1823–88) (1825–95)

Charles *m.* Elizabeth of Prussia
(1809–77) (1815–85)

Louis IV of Hesse *m.* Alice
(1837–92) (1843–78)

Louis of Battenberg, *m.* Victoria
1st Marquess of Milford Haven (1863–1950)
(1854–1921)

Ernst Ludwig *m.* Eleonore of Lick
(1868–1937) (1871–1937)

George, 2nd Marquess *m.* Nadejda, Countess de Torby
of Milford Haven (1896–1963)
(1892–1938)

Louis Mountbatten *m.* Edwina Ashley
(1900–79) (1901–60)

David, 3rd Marquess
of Milford Haven
(1919–70)

Georg, Grand Duke of Hesse *m.* Cecile
(1906–37) (1911–37)

Andrew (b. 1960)
m. Sarah Ferguson (div. 1996)

Edward (b. 1964)
m. Sophie Rhys-Jones

Zara (b. 1981)
m. Mike Tindall

Beatrice (b. 1988)
m. Edoardo Mapelli Mozzi

Eugenie (b. 1990)
m. Jack Brooksbank

Louise (b. 2003) James (b. 2007)

Mia (b. 2014) Lena (b. 2018) Lucas (b. 2021)

August (b. 2021)

EARLY LIFE

P RINCE PHILIP was born at the family home of Mon Repos, on the Greek island of Corfu, on 10 June 1921, the youngest of five children and the only son of Prince Andrew of Greece and Princess Alice of Battenberg. He was a great-great-grandson of Queen Victoria and Prince Albert on his mother's side and had connections to several of the royal families of Europe through both parents.

Prince Philip's father, Prince Andrew (1882–1944), also known as Andrea, was the son of George I, King of Greece, and Grand Duchess Olga Constantinovna, the niece of Emperor Alexander II of Russia. Prince Andrew's paternal grandfather was Christian IX of Denmark and so he was a prince of both Greece and Denmark. He was brought up at Tatoi, the royal palace outside Athens, and met his future wife, Princess Alice (1885–1969), the great-granddaughter of Queen Victoria, in 1902.

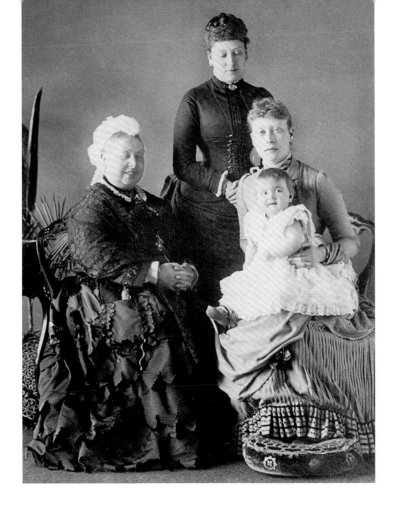

OPPOSITE: Prince Philip aged about one year, 1922

LEFT: Queen Victoria (left), Prince Philip's great-great-grandmother, photographed on 26 April 1886, with Prince Philip's grandmother, Princess Victoria, seated with Prince Philip's mother, Princess Alice of Battenberg, on her lap, while Philip's great-great-aunt, Princess Beatrice, stands behind

Princess Alice, who was born at Windsor Castle, was the eldest child of Prince Louis of Battenberg and Princess Victoria of Hesse and spent her childhood at the family home in Darmstadt, Germany, and also in Malta and London. Her mother was the daughter of Princess Alice, Queen Victoria's second daughter. Her father, who became a naturalised British subject at the age of 14, served in the Royal Navy and was appointed First Sea Lord in 1912. In 1917, due to anti-German sentiment, he changed his name and became known as Louis

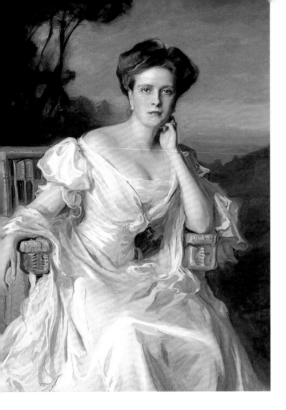

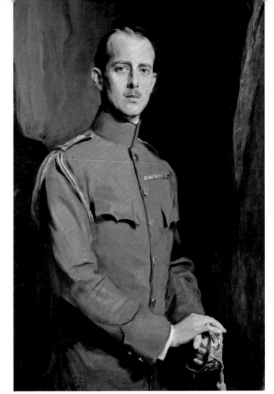

LEFT: Prince Philip's mother, Princess Alice, painted by Philip de László, 1907

RIGHT: Prince Philip's father, Prince Andrew of Greece, painted by Philip de László, 1913

Mountbatten, 1st Marquess of Milford Haven. Princess Alice was born profoundly deaf but she learned to lip-read in several languages and was known for her beauty and intelligence.

Following the young couple's marriage in 1903, they settled in Athens and over the next few years had four daughters: Margarita, Theodora, Cecile and Sophie. Prince Andrew served as an officer in the Greek army and saw front-line action during the Balkan Wars of 1912–13. Princess Alice, who travelled with him, nursed the sick and wounded. She was awarded the Royal Red Cross by King George V (1865–1936) in recognition of her services.

In 1913 Prince Andrew's father was assassinated and his elder brother, Constantine, became king. The family spent much of

the First World War in exile. On their return
to Greece in 1920 Prince Andrew resumed his
military duties and the family took up residence
at the villa of Mon Repos, which the Prince had
inherited from his father. In 1922 the Greeks
suffered a heavy defeat in the war against the
Turks. After a military coup, King Constantine
abdicated and Prince Andrew, accused of
treason, was imprisoned in Athens. On the
intervention of King George V and Lord Curzon,
the British Foreign Secretary, Prince Andrew
was released but was banished from Greece.
He was evacuated in the British naval vessel
HMS *Calypso*. Princess Alice was already on board
and, on the way to southern Italy, they stopped at
Corfu to pick up their five children. During the
passage Prince Philip, aged only 18 months, slept
in a crib made from a fruit crate. The family then
made their way through France to Paris.

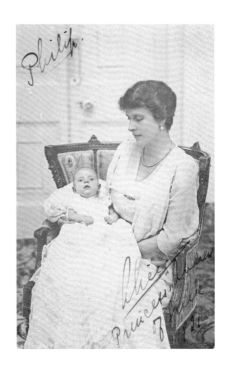

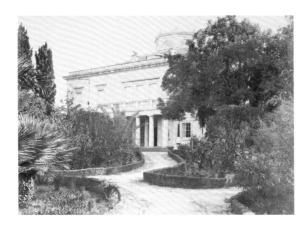

ABOVE: Prince Philip with his mother,
Princess Alice, at Mon Repos, Corfu, 1921.
The inscription is in Princess Alice's hand

LEFT: A view of the villa of Mon Repos in 1887,
where Prince Philip was born. The villa had
belonged to George I, King of Greece, Prince
Philip's grandfather, and was left to Prince Andrew,
Prince Philip's father, on the king's death in 1913

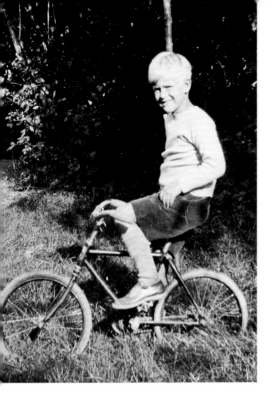

LEFT: Prince Philip on a
bicycle at Saint-Cloud, aged
around eight years old, 1929

RIGHT: Prince Philip
photographed in Paris in
the uniform of an Evzone
Guard, a ceremonial unit of
the Greek army, c.1929

The family settled in Saint-Cloud in the western suburbs of
Paris, where they lived in a house that belonged to Princess
George of Greece and Denmark (Marie Bonaparte), who was
married to Prince Andrew's elder brother, Prince George,
and was also the great-granddaughter of Napoleon's younger
brother, Lucien. The situation in Greece was still politically
volatile and in 1924, a year after King Constantine's death
in exile, Greece was declared a republic and there was no
possibility of the family returning to the country.

At the age of six Prince Philip started at The Elms, an
American school housed in the French author Jules Verne's
former home in Saint-Cloud, above the River Seine. Princess
Alice particularly wanted her son to learn good English at

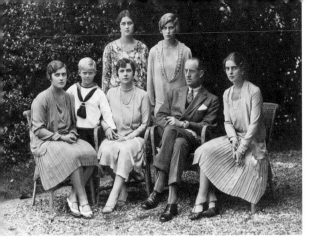

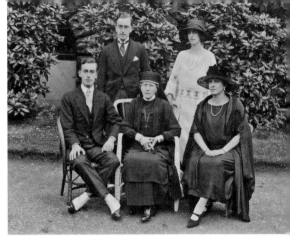

school. Although the family spoke English at home, the conversation would often move to other languages. Prince Philip was also fluent in French and German, and later recalled, 'If you couldn't think of a word in one language, you tended to go off in another'.

Around this time Princess Alice's mental health deteriorated. She was deeply affected by the family's flight from Greece and the impact of war on her wider family. In 1930 she was taken to the Bellevue sanatorium in Switzerland and Prince Philip was sent to Britain to stay with his maternal grandmother, Princess Victoria, the Dowager Marchioness of Milford Haven, who lived in apartments at Kensington Palace. His uncle, George, 2nd Marquess of Milford Haven and Princess Alice's elder brother, also took responsibility for Prince Philip, acting as his guardian between the ages of nine and 16.

In 1930 Prince Philip attended Cheam School in Surrey with his cousin, the Marquess's son, David, who was two years older and was to become a close friend. The Prince adapted to school quickly, despite being unfamiliar with

LEFT: Prince Philip's parents and sisters, photographed at Saint-Cloud in 1928 on the occasion of his parents' Silver Wedding anniversary. Standing, left to right: Princess Cecile and Princess Sophie. Seated, left to right: Princess Margarita, Prince Philip and his mother, Princess Alice, his father, Prince Andrew, and Princess Theodora

RIGHT: This photograph shows the family of Prince Philip's mother, the Mountbattens, c.1922. Standing, left to right: George, 2nd Marquess of Milford Haven, and his sister, Lady Louise Mountbatten (Prince Philip's uncle and aunt). Seated, left to right: Lord Louis Mountbatten (Prince Philip's uncle), Princess Victoria, the Dowager Marchioness of Milford Haven (Prince Philip's grandmother), and Princess Alice (Prince Philip's mother)

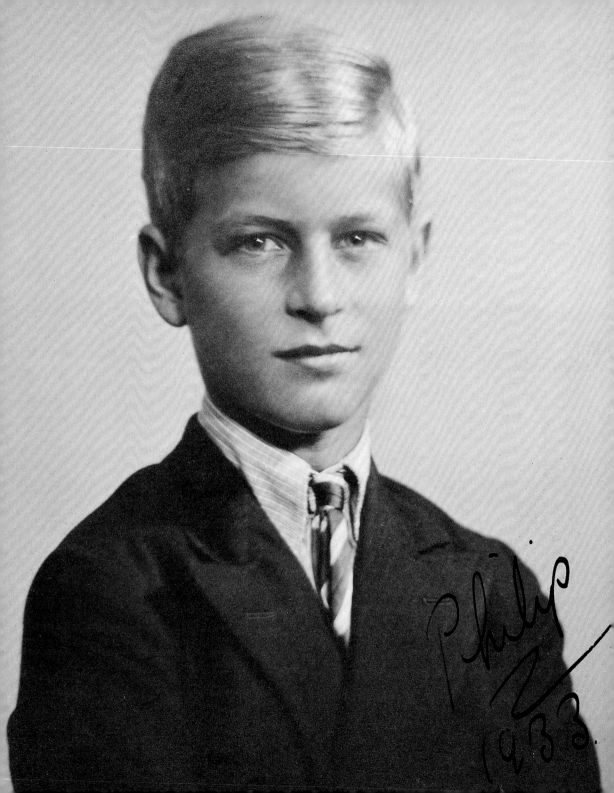

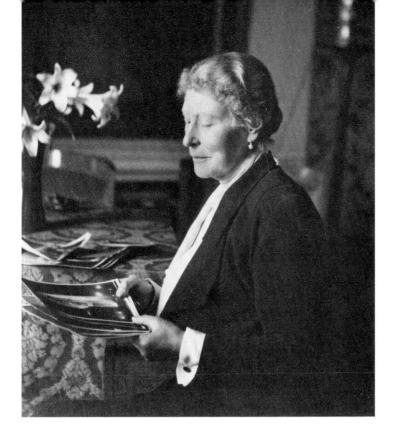

the English way of life. He was considered charming and the fact that he was good at games meant that he won acceptance and became popular. As well as spending time with the Milford Havens during the holidays Prince Philip also stayed with his grandmother at Kensington Palace. The Prince had limited contact with his mother, who was still in a sanatorium, and saw his father infrequently as Prince Andrew lived mostly in Paris or Monte Carlo. Prince Philip was in touch regularly with his four sisters and over the next three years he attended their weddings in Germany, all of them marrying German princes.

In 1933 Prince Philip left Cheam to attend the Schule Schloss Salem in Germany, a progressive boarding school that occupied

OPPOSITE: Prince Philip signed this photograph taken shortly before he left Cheam School aged 12, 1933

ABOVE: Prince Philip's grandmother, Princess Victoria, the Dowager Marchioness of Milford Haven, c.1925

part of a castle where his sister Princess Theodora lived with her new husband, Berthold, Margrave of Baden. The school's headmaster was Dr Kurt Hahn, a German Jew who had been educated at Oxford. Hahn believed children should be given the space and the freedom to discover their full potential. He was opposed to the Nazi Party, which was gaining prominence

Prince Philip at Gordonstoun, c.1937

in Germany at this time, and he was arrested by the Gestapo, but not charged. After the intervention of the British Prime Minister Ramsay MacDonald, Hahn was released and fled to Britain to avoid persecution. Prince Philip arrived at Salem shortly after this but the following year, with Nazism increasingly influencing life in Germany, his father decided his son should return to Britain and attend Gordonstoun, the school that Hahn had founded in Scotland.

Gordonstoun, near the Moray coast in Scotland, had 27 pupils when Prince Philip arrived in 1934 at the age of 13. The ethos of the school was pioneering and character-building, with the

Prince Philip at Gordonstoun, wearing the school uniform of open-necked grey shirt, pullover, shorts and long socks, c.1938

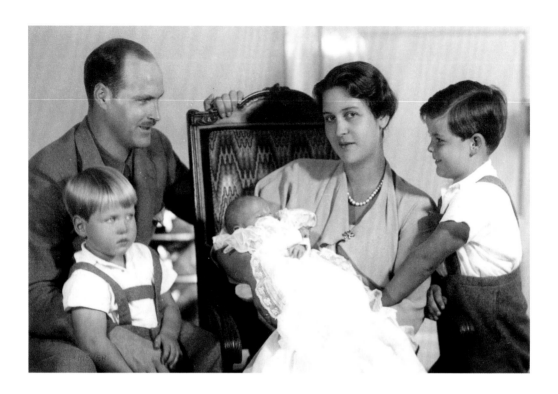

Prince Philip's sister, Princess Cecile, with her husband, Prince Georg, Grand Duke of Hesse, and their children, Ludwig, Alexander and Johanna, 1936

aim of encouraging every pupil to achieve their full potential. Conditions were spartan and physical activities played a large part in the timetable. Additionally, all pupils were expected to help on the estate and in the local community. The Prince responded well to the environment and developed a respect for the school and the headmaster. Hahn commented on his pupil, 'His most marked trait was his undefeatable spirit'.

Tragedy struck in 1937 and 1938, while Prince Philip was still at school. In November 1937 Prince Philip's sister, Princess Cecile, was killed in an air crash along with her husband, Prince Georg, Grand Duke of Hesse, their two young sons and their unborn child. Cecile and Georg's surviving daughter, Princess

Johanna, died of meningitis in 1939, at the age of only three.

Prince Philip's uncle and guardian, George Milford Haven, died of bone marrow cancer in April 1938. George's younger brother, Lord Louis Mountbatten (1900–79), stepped forward to act as guardian to his nephew. By 1938 Mountbatten had already had an impressive career in the Royal Navy and would go on to become First Sea Lord from 1954 until 1959, a position held by his father, Prince Louis of Battenberg, some 40 years earlier. Prince Philip often stayed at Adsdean, the Mountbattens' country home near Portsmouth, where they lived until Mountbatten's wife, Edwina, inherited Broadlands in Hampshire just before the outbreak of the Second World War. Following Gordonstoun, Prince Philip chose to follow his uncle into a naval career. Mountbatten arranged for the Prince to stay with a naval coach in Cheltenham to prepare for entry to the Royal Naval College, Dartmouth.

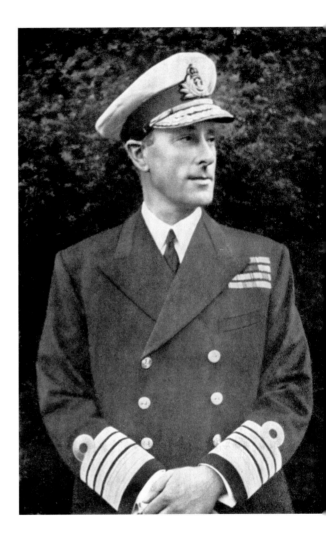

Lord Louis Mountbatten, Prince Philip's uncle and guardian, c.1930

NAVAL OFFICER

PRINCE PHILIP entered the Royal Naval College, Dartmouth, as a special cadet, aged 18, in May 1939. During his first term an important meeting took place when his uncle and guardian, Lord Mountbatten, attended King George VI and Queen Elizabeth on a visit to the naval college and Prince Philip met their eldest daughter, the young Princess Elizabeth.

After his first term at Dartmouth Prince Philip went back to Greece, where the monarchy had been restored in 1935. He was in Athens when war was declared between Britain and Germany on 3 September 1939. Although Greece was still a neutral country, Prince Philip's cousin, King George II of Greece, encouraged him to return to Britain to continue his naval training. On passing out from Dartmouth, he was awarded the King's Dirk as the best all-round cadet of the term and the Eardley-Howard-Crockett Prize as best cadet.

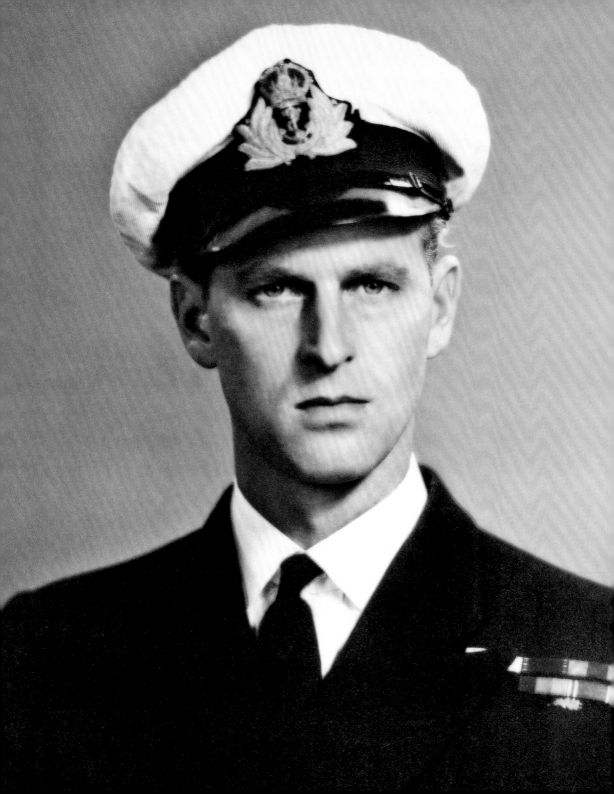

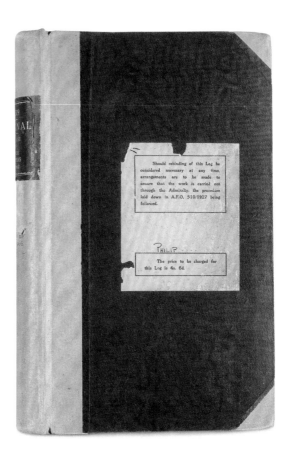

Prince Philip's midshipman's log, 1940–1, in which he describes the part he played in HMS *Valiant* at the Battle of Cape Matapan off the coast of Greece in March 1941, including his role operating the searchlight during night action

On New Year's Day 1940, he was posted as midshipman in HMS *Ramillies* in the Indian Ocean. He subsequently served in HMS *Kent* and HMS *Shropshire*. Greece joined the war on the Allied side after being invaded by Italy in October 1940, and in December 1940 Prince Philip was transferred to the battleship HMS *Valiant*. He saw action in the Mediterranean and played a key part operating *Valiant*'s searchlights during the Battle of Cape Matapan, off the south-west coast of the Peloponnesian peninsula of Greece. He recorded the details in his log: 'My

orders were that if any ship illuminated a target I was to switch on and illuminate it for the rest of the fleet ... She [the enemy cruiser] was seen complete in the light for only a few seconds as the flagship had already opened fire'. He was awarded the Greek War Cross and mentioned in dispatches.

After passing his Sub-Lieutenant's exams Prince Philip was posted to HMS *Wallace* at Rosyth, in Scotland. At the captain's request, in October 1942, he was promoted to First Lieutenant and second-in-command of the ship. At the age of 21 he was one of the youngest in the Royal Navy to hold that position. During the invasion of Sicily in 1943, the Prince showed courage and resourcefulness and saved *Wallace* from a night attack. He launched a raft with smoke floats that distracted the bombers and allowed the destroyer to sail away unseen.

Prince Philip spent the remainder of the Second World War as First Lieutenant in the new destroyer, HMS *Whelp*. In December 1944 he was in the Indian Ocean when he received a signal

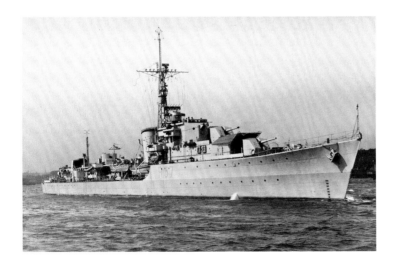

HMS *Whelp*, in which Prince Philip served as First Lieutenant in the Indian Ocean as part of the British Pacific Fleet until the end of the Second World War

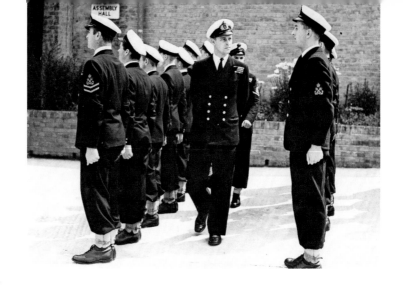

TOP: Prince Philip, then Lieutenant Philip Mountbatten, inspecting naval cadets at Corsham, Wiltshire, 1947

BOTTOM: Prince Philip teaching naval cadets at HMS *Royal Arthur*, Corsham, Wiltshire, 1947

from Mountbatten to say that his father, Prince Andrew, had died, aged 62. Prince Philip continued to serve in *Whelp* with the British Pacific Fleet and was present in Tokyo Bay on 2 September 1945, when the formal surrender of Japan was signed. He returned to Portsmouth in January 1946 and oversaw the decommissioning of *Whelp*. He was subsequently

given shore postings and by autumn 1946 he was at HMS *Royal Arthur*, at Corsham, near Bath, where he was an instructor to cadets at the Petty Officers' Training School.

After his marriage to Princess Elizabeth in November 1947 Prince Philip returned to naval duties, first at the Admiralty and then at the Royal Naval Staff College, Greenwich. In 1949 he was posted as First Lieutenant and second-in-command of the destroyer HMS *Chequers*, stationed in Malta. The following year he was promoted to Lieutenant Commander (later Commander) and given command of the frigate HMS *Magpie*, also in Malta. This was his final active naval appointment. In July 1951, due to King George VI's ill health and his need to support Princess Elizabeth with her increasing duties, Prince Philip returned from Malta. His naval career ended when Princess Elizabeth acceded to the throne as Queen Elizabeth II in February 1952.

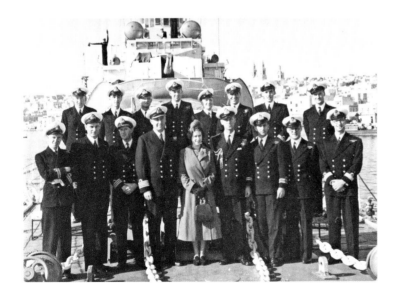

A group portrait aboard HMS *Chequers*, moored off Malta, on Boxing Day 1949, with Princess Elizabeth and Prince Philip and officers on deck

MARRIAGE AND FAMILY LIFE

Prince Philip was a third cousin of Her Majesty The Queen, and this close family connection meant that they had met on several occasions in the years prior to their engagement. Their first significant meeting took place in July 1939 at the Royal Naval College, Dartmouth, where the Prince was a special cadet. King George VI was undertaking an inspection, accompanied by Queen Elizabeth and their two daughters, Princess Elizabeth, aged 13, and her sister Princess Margaret, aged nine. Prince Philip hosted the young Princesses and joined the royal party for tea on board the Royal Yacht *Victoria and Albert*.

The cousins kept in touch and in 1943 the Prince spent Christmas with the Royal Family at Windsor Castle. He attended the annual pantomime, *Aladdin*, in which Princess Elizabeth took the title role. Prince Philip also joined in the family celebrations, including charades and dancing after dinner on Boxing Day.

Prince Philip showing the 13-year-old Princess Elizabeth around the Royal Naval College, Dartmouth, in 1939

The Prince's presence at Windsor over Christmas was reported in the press, fuelling rumours about a romance between himself and Princess Elizabeth. Soon afterwards, Prince Philip's cousin, King George II of Greece, asked King George VI if the Prince might be considered as a suitor for his daughter. Initially the request was put on hold as Princess Elizabeth was deemed too young. From 1946 onwards Prince Philip was a frequent visitor to Buckingham Palace and during

COURT CIRCULAR

BUCKINGHAM PALACE, July 9

It is with the greatest pleasure that The King and Queen announce the betrothal of their dearly beloved daughter The Princess Elizabeth to Lieutenant Philip Mountbatten, R.N., son of the late Prince Andrew of Greece and Princess Andrew (Princess Alice of Battenberg), to which union The King has gladly given his consent.

that summer he joined the Royal Family at Balmoral Castle, in Aberdeenshire. Press speculation about a possible engagement increased once it became known the Prince had applied to become a naturalised British subject. On 18 March 1947 the *London Gazette* announced his change of nationality. On becoming British Prince Philip renounced his royal title and right of succession to the Greek throne, to which he was sixth in line. Taking his maternal grandfather's name, Mountbatten, he became known as Lieutenant Philip Mountbatten.

The engagement between Princess Elizabeth and Lieutenant Philip Mountbatten, RN, was officially announced in the Court Circular on 9 July 1947. The platinum and diamond engagement ring featured stones taken from a tiara that had belonged to the Prince's mother, Princess Alice. The following day the

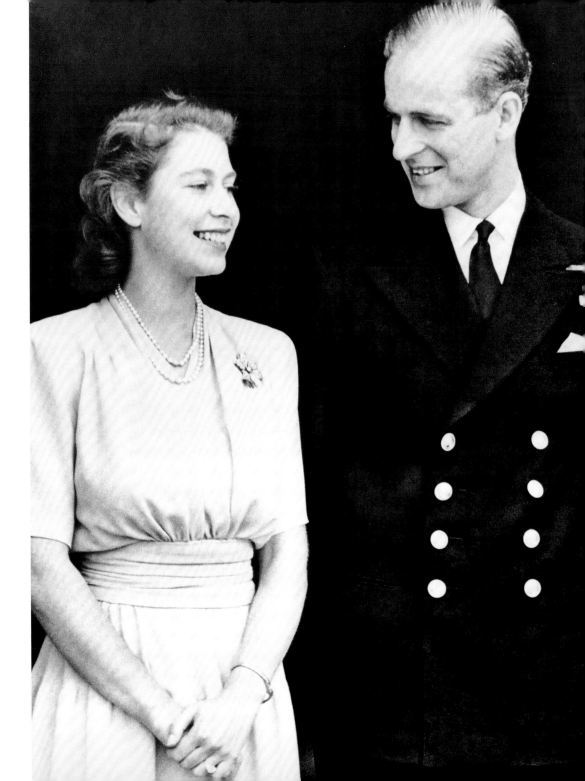

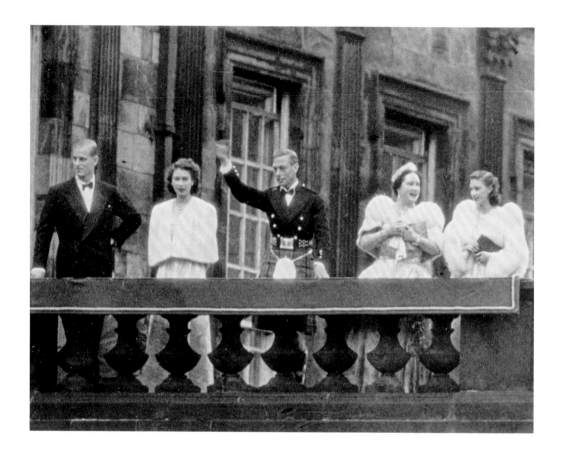

Princess Elizabeth and
Lieutenant Philip Mountbatten
at the Palace of Holyroodhouse,
Edinburgh, with King George VI,
Queen Elizabeth and Princess
Margaret, 1947

engaged couple made their first appearance at a Garden Party
at Buckingham Palace, and a week later they accompanied
the king and queen on their annual visit to the Palace of
Holyroodhouse in Edinburgh.

The press reacted to the engagement favourably and
interest in the Prince increased dramatically. Much was made
of his British connections and education, and his wartime
service in the Royal Navy. He continued to teach at Corsham,
but stayed at Kensington Palace when in London, and was

provided with a secretary, a personal protection officer and a valet. The Prince also undertook a number of duties with the Princess, including a visit to Clydebank for the naming of the new Cunard liner *Caronia*. In October Prince Philip was received into the Church of England by the Archbishop of Canterbury, and a month later was appointed a Knight of the Garter. On the eve of the wedding he was named His Royal Highness and created Baron Greenwich, Earl of Merioneth and Duke of Edinburgh.

Lieutenant Philip Mountbatten, RN, leaving Kensington Palace for his wedding at Westminster Abbey, accompanied by his cousin and groomsman, David Mountbatten, 3rd Marquess of Milford Haven

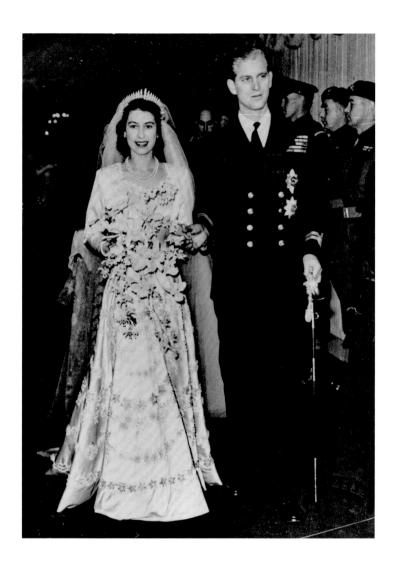

Princess Elizabeth and
Prince Philip on their wedding
day, 20 November 1947.
Prince Philip wore his naval
uniform and naval ribbons,
the Star of the Order of the
Garter and the Star of the
Greek Order of the Redeemer

With rationing still in place after the war and an unusually
hard winter in 1946–7, it was agreed that the wedding should
not be ostentatious. Despite this, wedding presents poured
in and 1,500 were put on public display at St James's Palace.

The wedding took place at Westminster Abbey in London on 20 November 1947. After the service the bride and groom emerged from the Abbey to huge applause. Having processed to Buckingham Palace through crowd-lined streets, the newly weds made many appearances on the balcony, to the delight of the well-wishers below. The wedding breakfast for 150 guests was served in the Ball Supper Room. The elaborate decorations on one of the wedding cakes paid tribute to Prince Philip's naval service.

The royal wedding party photographed at Buckingham Palace

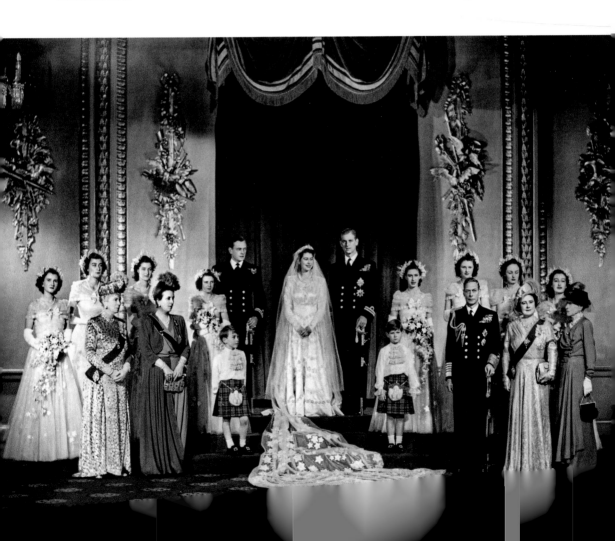

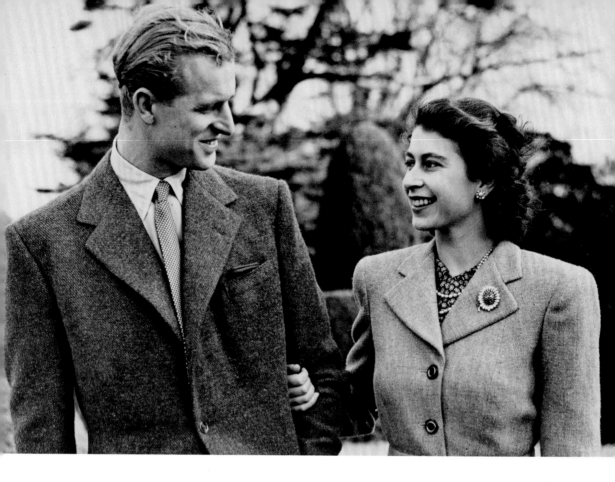

After their marriage
Prince Philip and
Princess Elizabeth
were known as The Duke
and Duchess of Edinburgh.
The couple are pictured
here at Broadlands during
their honeymoon, 1947

Their honeymoon was spent at Broadlands, the Mountbattens' home in Hampshire, and in Scotland. The royal couple's London residence, Clarence House, was still in need of renovation following bomb damage during the war so they rented Windlesham Moor, near Sunningdale in Berkshire as a family home, and spent the working week in their apartment at Buckingham Palace. For the next four years Prince Philip combined his day job in the Royal Navy with royal duties, such as attending charity events, business meetings and factory visits, as well as accompanying Princess Elizabeth on a very successful visit to Paris. He was

noted as a good speaker and his charm and friendliness proved an asset at such occasions. A journalist from the *London Evening Standard* reported, 'The more I hear Prince Philip speak in public, the more impressed I am by his ability'.

Prince Philip and Princess Elizabeth's first child, Prince Charles, was born on 14 November 1948 at Buckingham Palace. Eight months later, the young couple and their baby son moved into Clarence House, which was to be their primary residence until Princess Elizabeth's accession to the throne. Here they were able to enjoy family life in their own home.

Prince Philip and Princess Elizabeth with Prince Charles as a baby, 1949

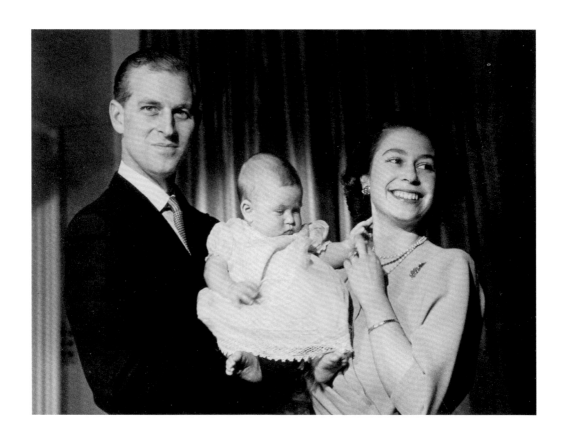

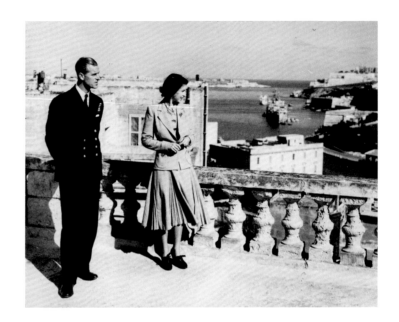

Prince Philip and
Princess Elizabeth at
the Villa Guardamangia,
Malta, 1949

In the autumn of 1949 Prince Philip returned to active
service in the Royal Navy, and the couple divided their
time between Malta and London. While HMS *Chequers* was
undergoing a refit, Prince Philip stayed with the Mountbattens
at the hilltop Villa Guardamangia in Malta. Princess Elizabeth
joined her husband for their second wedding anniversary.

Prince Philip returned to London on leave in the summer to
await the birth of their second child, Princess Anne, who was
born on 15 August 1950. In July 1951 the couple left Malta for
good as Princess Elizabeth took on more of her father's public
duties. Their first major overseas tour together was to Canada
in October 1951. Two months after returning from North
America, they set off on a Commonwealth tour to Australia and
New Zealand, via East Africa and Sri Lanka. On 6 February 1952,

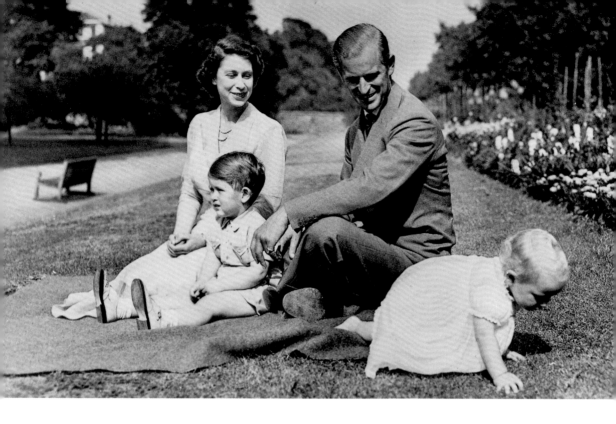

ABOVE: Princess Elizabeth and Prince Philip with Prince Charles and Princess Anne in the garden at Clarence House, 1951

LEFT: Princess Anne, The Queen, Prince Charles, Prince Philip and Prince Andrew with the infant Prince Edward in his pram at Frogmore House in Windsor Home Park, 1965

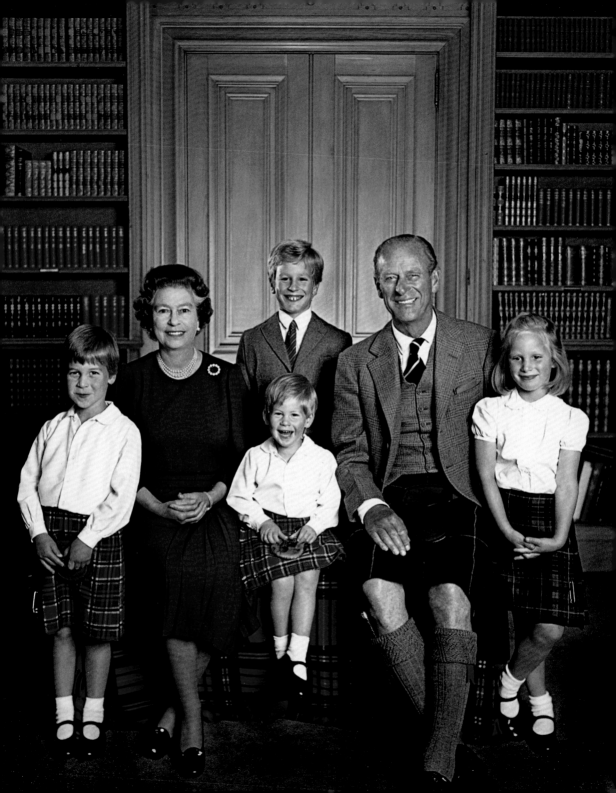

news of the king's death reached Kenya and the royal party returned to London.

Following the accession, The Queen, Prince Philip and their two young children moved to Buckingham Palace. Their two younger children were born at Buckingham Palace: Prince Andrew on 19 February 1960 and Prince Edward on 10 March 1964.

At their private residences of Sandringham House in Norfolk and Balmoral Castle in Aberdeenshire, The Queen and Prince Philip were able to relax with their family. Christmas would be spent at either Windsor or Sandringham, and The Queen and Prince Philip would travel to Scotland every summer for their annual holiday at Balmoral. These traditions continued as the family grew, and Prince Philip greatly enjoyed the time he spent relaxing with his grandchildren and great-grandchildren.

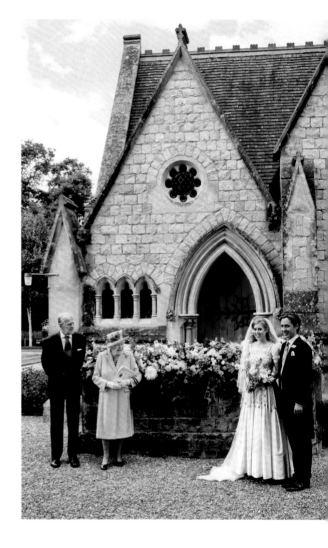

OPPOSITE: The Queen and Prince Philip with their four eldest grandchildren, Prince William, Prince Harry, Peter Phillips and Zara Phillips, in the Library at Balmoral Castle, 1987

ABOVE: The Queen and Prince Philip at the wedding of their granddaughter, Princess Beatrice, to Mr Edoardo Mapelli Mozzi, 17 July 2020

ROYAL CONSORT

I N 2009 PRINCE PHILIP became the longest serving royal consort in British history. There is no formal description of the role that the spouse of the British monarch should fulfil, beyond supporting the work of the sovereign and the Royal Family. This may include a role as Privy Councillor or informal adviser, patronages and charity work, support for the armed forces and attending official engagements, either alone or with the monarch or other members of the Royal Family.

Coronation

Two committees of the Privy Council were convened to organise The Queen's Coronation of 1953, one of which was the Coronation Commission, chaired by Prince Philip. Comprising 35 officials, including the Archbishop of Canterbury, the Prime

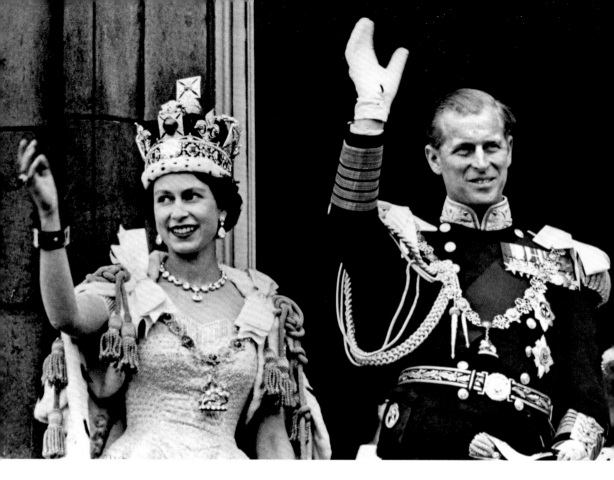

Minister and the Lord Chamberlain, the first meeting was held at St James's Palace on 5 May 1952. The Coronation was scheduled for 2 June 1953 to allow sufficient preparation time, including at Westminster Abbey, which was undergoing post-war restoration.

On 30 May 1953 the specially chartered ferry *Maid of Orleans* brought nearly 200 guests across the Channel and then by train to Victoria Station, London, where they were received by Prince Philip. The Prince also visited all the contingents of troops from the Dominions and Commonwealth who were

Upon their return to Buckingham Palace after the Coronation, The Queen and Prince Philip made several appearances on the balcony

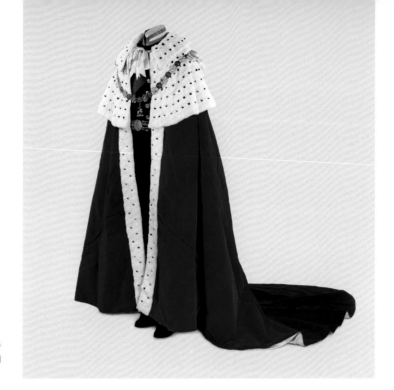

Prince Philip's Coronation robes were made of red silk velvet and black-and-white ermine

in London to take part in the Coronation procession. Several of these trips were undertaken by helicopter, a new mode of transport for the Royal Family.

Prince Philip was the first to pay homage to the newly crowned monarch during the Coronation Service. He wore naval uniform under his Coronation robes. Following the crowning, the Prince approached Her Majesty, knelt before her while his Page assisted with the long robe, and pledged his allegiance to The Queen with the words:

> I Philip, Duke of Edinburgh, do become your liege man of life and limb, and of earthly worship, and faith and truth I will bear unto you, to live and die against all manner of folks. So help me God.

He then rose and kissed her left cheek. It was this moment that Terence Cuneo depicted in his official painting of the Coronation.

The Archbishop of Canterbury offered a prayer for Prince Philip:

> multiply thy blessings upon this thy servant PHILIP
> who with all humble devotion offers himself
> for thy service in the dignity to which thou hast called him.
> Defend him from all dangers, ghostly and bodily;
> make him a great example of virtue and godliness,
> and a blessing to The Queen and to her Peoples.

The artist Terence Cuneo based this painting of the Coronation on sketches he made from his seat high above the choir in Westminster Abbey, capturing the moment when Prince Philip paid homage to The Queen

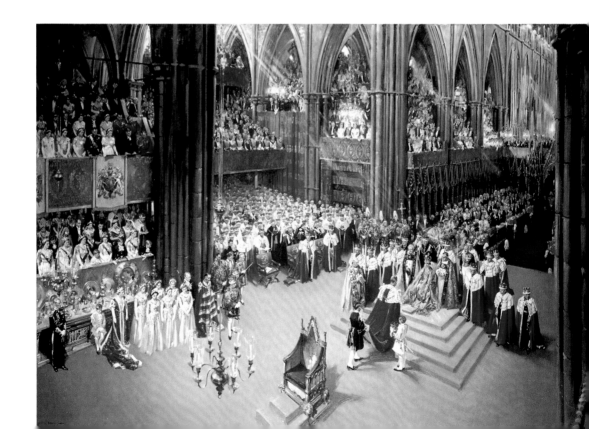

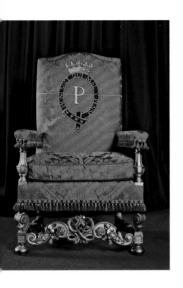

Prince Philip's Chair of Estate was made in 1953, inspired by English chairs of the seventeenth century

One of the most significant decisions made by the Coronation Committee, and particularly encouraged by Prince Philip, was to allow the BBC to broadcast live three parts of the service: the recognition, crowning and homage.

The Queen and Prince Philip appeared on the balcony of Buckingham Palace four times on Coronation Day to greet the crowds. Amid the excitement came news of another cause for celebration: it was announced that same morning that Edmund Hillary and Tenzing Norgay had reached the summit of Mount Everest, the first climbers ever to stand on top of the highest mountain in the world. In 1954, when asked about his most memorable experience, Prince Philip cited hearing this news.

Following the Coronation, The Queen's Chair of Estate was placed on the dais in the Throne Room at Buckingham Palace. A matching chair with the cipher 'P' for Philip was made to accompany it.

Consort

When Prince Philip became consort in 1952, his predecessor in that role was Prince Albert, husband of Queen Victoria and Prince Philip's great-great-grandfather. Many of Prince Philip's early patronages were inherited from his father-in-law, King George VI, but he also undertook engagements focused on the charities, causes and places in which he had a personal interest.

Princess Elizabeth and Prince Philip were both made Privy Councillors shortly after their official visit to Canada in 1951. This meant they could form part of the small body that acts as official advisers to the monarch. The Prince was also the longest serving Privy Councillor in Canada, having been installed in 1957.

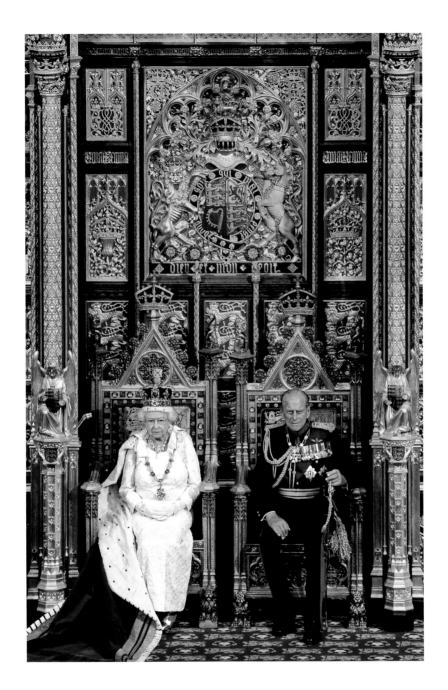

The Queen and
Prince Philip during
the State Opening
of Parliament, 2014

Prince Philip holds the hand of the young John Kennedy at the unveiling of the memorial to his father, US President John F. Kennedy, at Runnymede, 1965

In 1952 Prince Philip watched a debate in the House of Commons from the Peers' Gallery, the first member of the Royal Family to do so since Prince Albert in 1846. He had earlier been introduced to the House of Lords in 1948, although he never spoke and his position was rescinded as a result of the House of Lords Act 1999. On 9 June 1948 he was presented with the Freedom of the City of London. The Prince accompanied The Queen to State Openings of Parliament between 1953 and his retirement in 2017, as well as the inaugurations in 1999 of the National Assembly for Wales (now the Senedd Cymru) in Cardiff and the Scottish Parliament in Edinburgh.

Prince Philip's representative duties, travels and patronages involved an array of formal dress, uniforms, insignia and ties, and he always tried where practical to conform to the dress code of his hosts. In warmer climes he wore tropical uniform and when visiting troops on exercise he wore combat dress. When attending an engagement in a lounge suit his neck tie often reflected the club or organisation he was visiting. Prince Philip amassed almost 800 ties over the course of his life; these, and his uniforms, were kept in immaculate condition by his valet.

On 9 April 1952 it was confirmed that all The Queen and Prince Philip's children, and the British royal house, would

In 1994, on the fiftieth anniversary of the D-Day landings, Prince Philip accompanied The Queen to Arromanches in northern France to greet veterans, travelling in a modified Range Rover

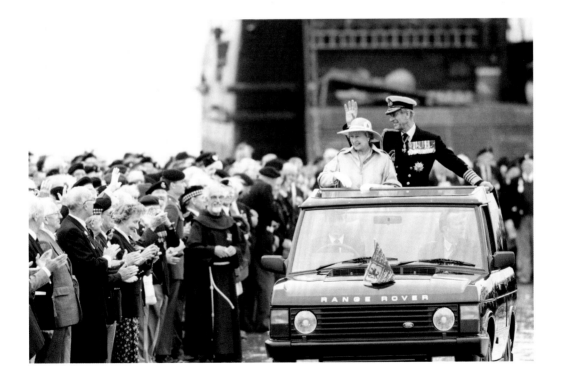

LEFT: Prince Philip wears
tropical uniform in
Bermuda, 1959

RIGHT: The royal couple share
a light-hearted moment as a
swarm of bees temporarily
stops The Queen's review of
the Queen's Company of the
Grenadier Guards at Windsor
Castle, 2003. Prince Philip is in
the uniform of Colonel of the
Grenadier Guards

continue to use the name of Windsor introduced in 1917 by
King George V. In 1960, letters patent enabled the descendants
of The Queen and Prince Philip who did not hold other titles to
use the surname Mountbatten-Windsor, in acknowledgement
of the surname adopted by the Prince following his
renouncement of his Greek titles.

Prince Philip was the first member of the Royal Family to
give a television interview in 1961. He made films speaking
about his 1956–7 World Tour for distribution to schools and
for leaders of the Duke of Edinburgh's Award. In 1966, with
the support of the Prince, the interiors of the royal residences,
many of which had never been seen on television before, were

filmed for the joint broadcast by the BBC and ITV of Kenneth Clark's *Royal Palaces of Britain*.

In his work Prince Philip was supported by a small team of staff, including a Private Secretary. The Prince wrote his own speeches and, on occasion, issued his own statements of support or sympathy in reaction to current events. His office co-ordinated his correspondence and (until his official retirement) planned his extensive programme of engagements.

As with other members of the Royal Family, all the official engagements carried out by Prince Philip were noted in the Court Circular, a daily report issued to the press and recorded in ledgers that are eventually passed to the Royal Archives.

During walkabouts, Prince Philip would often lift young children over security barriers, to enable them to present flowers to The Queen. This moment was captured during a visit to Lancashire in 1999

RESIDENCES AND
RESTORATION

K ING GEORGE VI suggested that, following their wedding, Princess Elizabeth and Prince Philip should use Clarence House, part of St James's Palace, as their London home, and the neo-classical Sunninghill Park, near Ascot, as a country residence. Both houses still bore the marks of wartime use: Clarence House as a Red Cross and St John Ambulance Brigade headquarters and Sunninghill by the United States Air Force. Clarence House had also been severely shaken by a high-explosive bomb in 1944.

Clarence House had last been occupied by Queen Victoria's son, the Duke of Connaught, who died in 1942. Under the close eye of the future residents, hot air convection heating was installed under the windows, gas cooking was introduced to the kitchens and the whole house was rewired. The royal couple moved in on 4 July 1949 and Clarence House remained their official London residence for nearly three years.

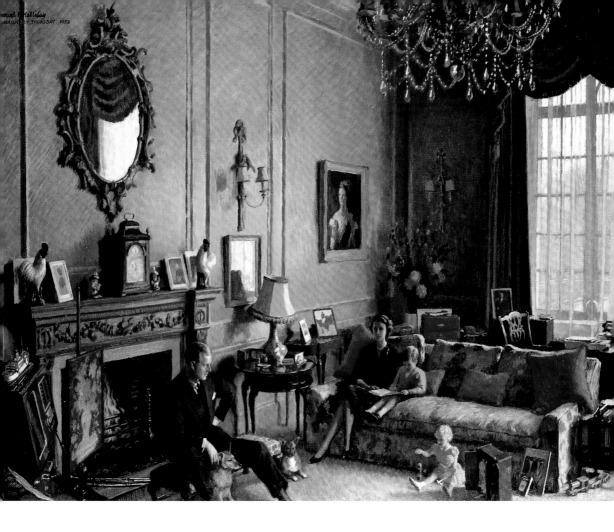

In Prince Philip's sitting room the wall panelling and writing desk were of white maple presented by Canadian Pacific Railway and included an innovative folding drawing table. Portraits by Philip de László of his parents and his grandfather, the Marquess of Milford Haven, were hung close to a model of *Prince Louis*, the schooner owned by Gordonstoun in which the Prince had regularly sailed as a boy. The library was furnished with a naval theme: Norman Wilkinson's portrayal

Princess Elizabeth's sitting room at Clarence House forms the backdrop to this family scene, commissioned from Edward Halliday. It shows The Queen and Prince Philip prior to undertaking the first public engagement of the new reign, the Maundy Service at Westminster Abbey, April 1952

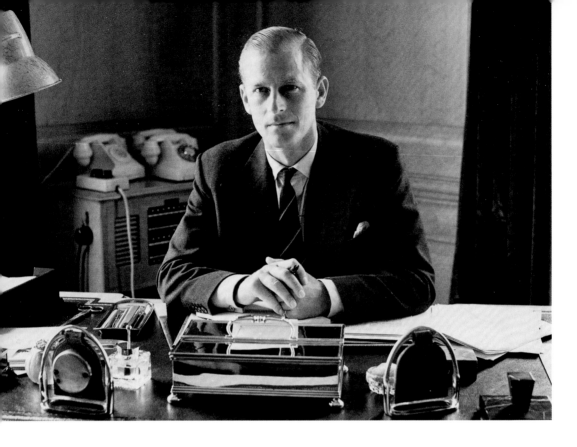

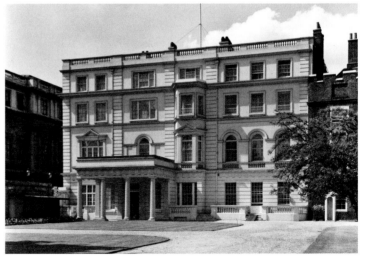

ABOVE: Prince Philip seated at his desk in Clarence House, 1951

RIGHT: Clarence House, pictured in 1949, was mostly built in the early nineteenth century for William IV when Duke of Clarence, and was altered in the later nineteenth century

of HMS *Vanguard* was hung above the chimney piece, and the loose chair covers were made from chintz decorated with sailing ships, ropes and anchors. The Prince's bedroom was panelled in pale Scottish sycamore presented by the City of Glasgow. The most modern alterations were in the form of a 25-seat cinema – a wedding gift – and a bar for serving drinks.

Sunninghill Park was destroyed by a fire in August 1947, so a two-year lease was taken on Windlesham Moor, another country home close to Windsor. The couple used this early twentieth-century house at the weekends, and it was the location for the first short film released to the public of Princess Elizabeth and Prince Philip with the young Prince Charles.

Three months after the accession in 1952, The Queen and Prince Philip moved with their family to Buckingham Palace. Prince Philip installed a dictograph at the Palace, which formed an intercom system connecting The Queen, Prince Philip, senior members of the Royal Household and locations such as the door used by visitors to the Palace. Radio telephones were fitted in the royal cars and a kitchen was added in the private apartments.

Under the direction of Prince Philip, a review of Buckingham Palace at the time of the Coronation by the modernist architect Thomas Bennett rearranged rooms to take advantage of the sunlight.

In 1957, Prince Philip invited the architect Sir Hugh Casson to redesign his study at the Palace. The walls were covered with fabric by Sekers that the Prince had seen on a visit to the Council for Industrial Design. Contemporary rosewood furniture designed by Michael Knott and made by Ernest Joyce was fitted along the window wall overlooking the

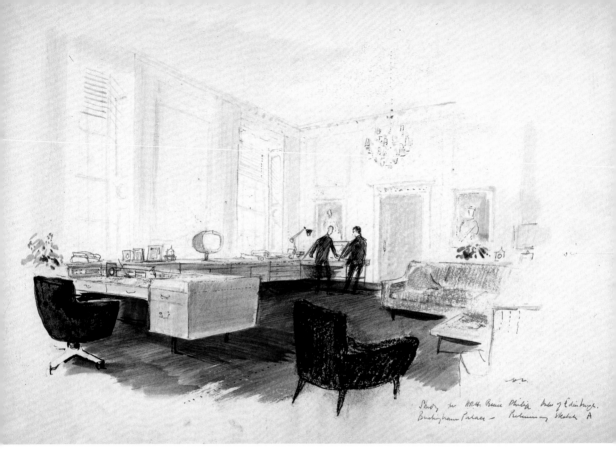

Sir Hugh Casson's sketch
for Prince Philip's study at
Buckingham Palace, 1957

Palace garden. The room also had a modern television set,
a tape deck, turntable and radio, and automated curtains.

Prince Philip played a major part in the development of
The Queen's Gallery at Buckingham Palace to provide public
access to the Royal Collection. In 1957 The Queen and Prince
Philip proposed that the building in the south-west corner
of Buckingham Palace, originally designed by John Nash in
1825–30 as a conservatory but converted for use as a private
chapel under Queen Victoria, should become a public gallery.
Prince Philip contributed ideas to the design, which allowed

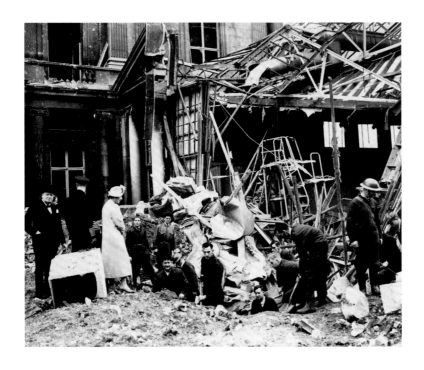

King George VI,
Queen Elizabeth and
Prime Minister
Winston Churchill
view bomb damage at
Buckingham Palace,
13 September 1940

The first Queen's Gallery,
Buckingham Palace,
as it appeared on its
opening in 1962

the transformation from a chapel to a public gallery and also its conversion for worship again if required. The Queen's Gallery opened in 1962 with an exhibition, *Treasures from the Royal Collection*, that was seen by 200,000 visitors. The Gallery was rebuilt in the 1990s and once again the Prince was involved in discussions about its design.

Casson was also commissioned by The Queen and Prince Philip in the 1960s to replace a chinoiserie-style guest suite at Windsor Castle with bright, modern interiors. The suite includes mid-century contemporary furniture and decorative arts by makers including Heal's, Lucie Rie and Margaret Hine, and the walls are hung with pictures by Barbara Hepworth, Ivon Hitchens and Alan Davie.

In 1966 Prince Philip and the Dean of St George's Chapel, Robert 'Robin' Woods, co-founded St George's House at Windsor Castle. The organisation was established as a study centre where clergy and laity could discuss topics where religious morality and modern ethics, particularly in business or industry, aligned. Housed in two canons' houses close to the Chapel, the second strand of its mission was the provision of mid-career training for Church of England clergy, some of whom by the 1960s were serving a world much changed from their time at theological college. Prince Philip served on its Council from its foundation and made frequent contributions to its annual lecture programme.

In 1958, Prince Philip approached the composer Benjamin Britten to write a piece of music for St George's Chapel, Windsor Castle. *Jubilate Deo* (in C) was his response, and this has been sung frequently by St George's Chapel choir, including at Prince Philip's birthday services and his funeral.

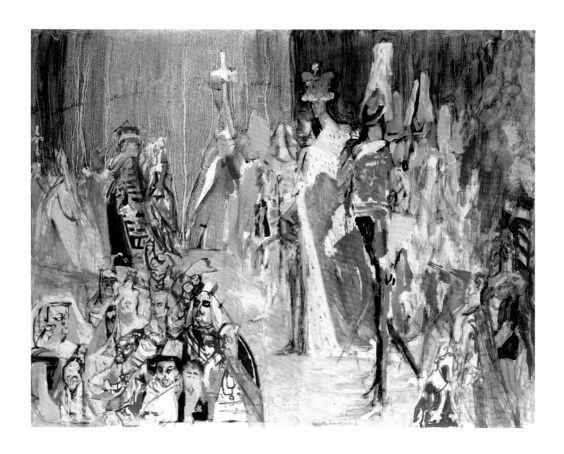

One of a series of canvases by Feliks Topolski,
dated 1959–60, forming a frieze depicting
The Queen's Coronation, which shows
Prince Philip's arrival at Westminster Abbey.
Among the earliest commissions of modern
art by Prince Philip, the almost 20-metre-long
frieze is one of the first works of art seen by
summer visitors to Buckingham Palace as
they enter the Lower Corridor

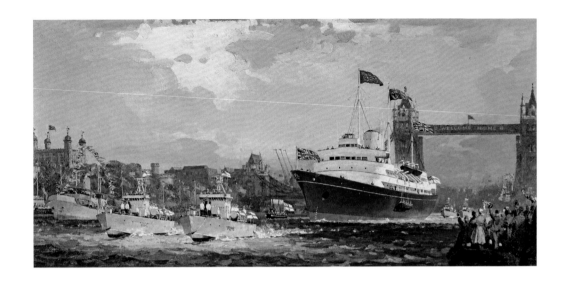

HMY *Britannia*

Leslie Arthur Wilcox painted HMY *Britannia* entering the Pool of London having just passed under Tower Bridge after her first voyage, 1954

On 16 April 1953 the new Royal Yacht, named *Britannia*, was launched by The Queen. The instruction to build HMY *Britannia* was received by the Clydebank shipyard, John Brown & Co., in February 1952, only two days before the death of King George VI, so the responsibility of overseeing the commissioning fell to The Queen. *Britannia* was to have complete ocean-going capacity and to be designed as a royal residence in which to entertain guests around the world. Prince Philip took a keen interest and active role in both the technical aspects of *Britannia*, drawing on his own practical naval experience, and the interior design of the Royal Apartments. He went on to describe *Britannia* as a 'splendid example of contemporary British design and technology'.

The royal couple wished for an unostentatious interior with a style that reflected the austerity of the post-war period, and Sir Hugh Casson's elegant designs had a suitable lightness of touch. He noted the Prince 'wanted everything to be in the spirit of the present age', and later recalled that 'the overall idea was to give the impression of a country house at sea'.

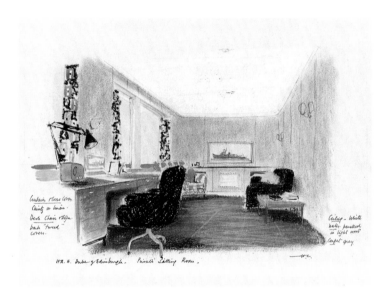

ROYAL ACADEMY OF ARTS,
PICCADILLY, LONDON, W1V ODS

Telephone: 01-734 9052
Cables: Royacad, London

TOP: Sir Hugh Casson's design for Prince Philip's sitting room on HMY *Britannia*, 1952

BOTTOM: Sir Hugh Casson's drawing of corgis looking at HMY *Britannia* on a letter to Prince Philip

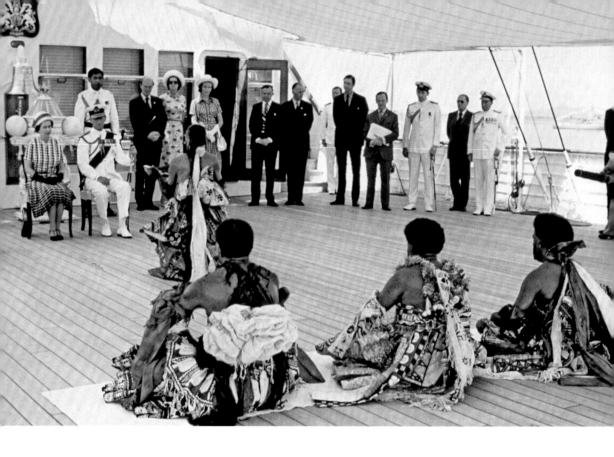

A traditional greeting for
The Queen and Prince Philip
on board HMY *Britannia* on
arrival in Fiji, 1977

The result was a series of apartments that reflected the
couple's taste and style, including white walls and gilt details
around the cornice in the public rooms. As well as installing
contemporary furniture and simple chandeliers and light
fittings, Sir Hugh Casson incorporated pieces from RY *Victoria
and Albert III*, *Britannia*'s predecessor built for Queen Victoria,
whose service had ended in 1939.

Prince Philip's sitting room and bedroom embodied his own
taste and interests. The sitting room was panelled in teak and
had a red leather-topped mahogany desk. Above the desk was
a model of HMS *Magpie*, a reminder of the Prince's first naval

command in 1950. The Prince's bedroom was fitted with dark mahogany furniture.

The distinctive and very visible blue paint on *Britannia*'s hull was chosen by The Queen and Prince Philip, inspired by the colour of their racing yacht, *Bluebottle*. This made *Britannia* distinct from her predecessors, which were all painted black.

The couple first sailed in *Britannia* at Tobruk, in Libya, on 1 May 1954, for the final stage of a Commonwealth tour. During almost 44 years *Britannia* made more than 700 overseas visits. On 25 February 1994 *Britannia* completed one million miles as she steamed across the Caribbean, and The Queen and Prince Philip attended a special ceremony in the Engine Room. *Britannia* was also the setting for many relaxed family holidays, including an annual cruise around the Western Isles of Scotland.

Britannia was decommissioned in 1997 and is now berthed at the Port of Leith, Edinburgh.

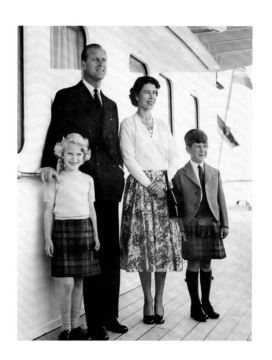

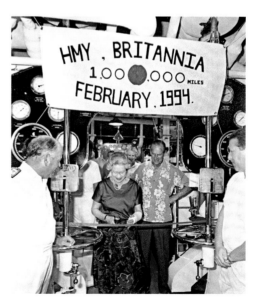

TOP: The Queen, Prince Philip, Prince Charles and Princess Anne on board HMY *Britannia*, 1956

BOTTOM: The Queen cuts a ribbon to celebrate HMY *Britannia*'s one millionth mile, 1994

Windsor Castle Restoration

On 14 November 1992 a fire started by an electric light too close to a curtain in the private chapel at Windsor Castle burned through the north-east corner of the State and Semi-State Apartments. Royal Household staff and contractors working at the Castle escaped with minor injuries. A small number of works of art, too large to be removed, were lost, along with almost all the interiors of several State Rooms, including St George's Hall, and some service areas.

In early December Prince Philip convened and chaired the Restoration Committee to oversee the reinstatement of the building while the structure was drying out following the fire service's dousing of the flames. The Prince expressed his support for a full restoration of the nine affected State Rooms, rather than a redesign, based on the fact that the paintings and works of art almost entirely survived and their previous placement was well recorded. Most of the movable works of art had been removed from the Castle prior to the rewiring project during which the accident had occurred. The chapel had been used regularly for private services, christenings and weddings, but as it was situated between St George's Hall and the private and Semi-State Apartments, this resulted in an inconvenient processional route through the chapel on formal occasions. The fire provided an opportunity to reassess this layout.

OPPOSITE: American artist George Weymouth was commissioned to paint this portrait of Prince Philip as Chair of the Restoration Committee. He is depicted in the fire-damaged St George's Hall beside one of the props holding up the remnants of the carved interior, with a roll of architectural plans under his arm. Sunlight, reflecting a sense of future hope, floods in through the archway that leads to the Long Walk. Using artistic licence, Weymouth turned this archway 90 degrees

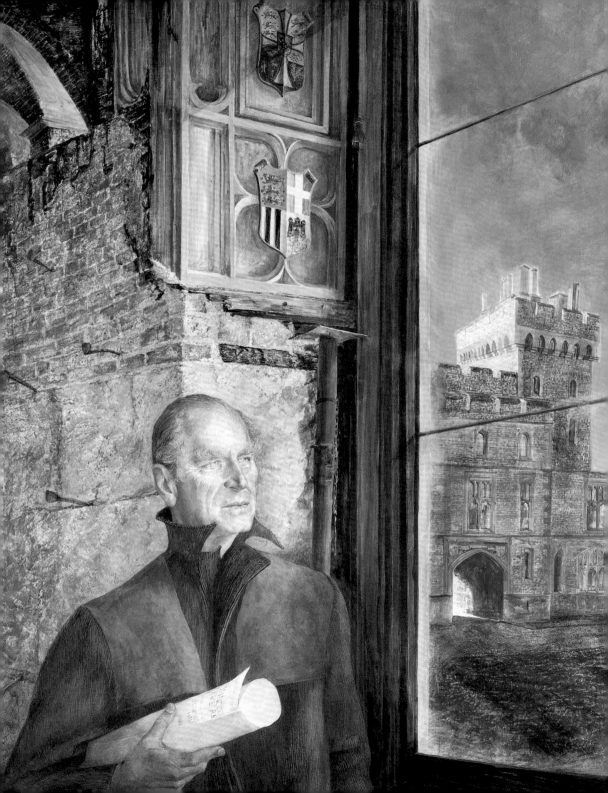

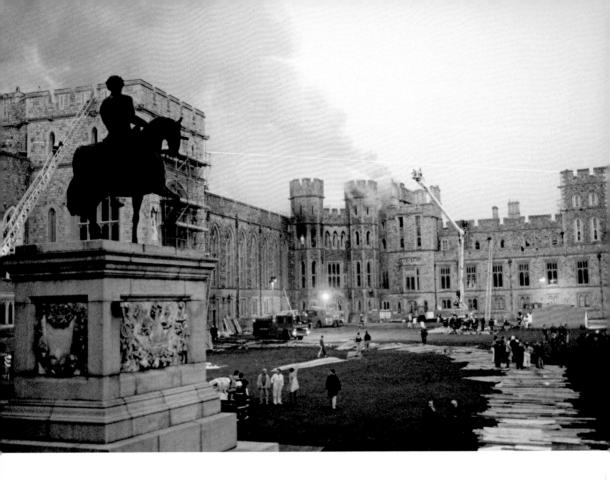

Windsor Castle
on the day of the fire,
14 November 1992

Under Prince Philip's chairmanship the Committee oversaw
the archaeological investigation that retrieved from the debris
many of the architectural fragments required for the restoration
of the interiors. It was decided to change the awkward siting
of the private chapel and use this space as an octagonal lobby
with a top lantern, fitted with display cases for some of the
magnificent silver gilt in the Royal Collection. This room has
become part of the visitor route of the Castle. Its floor was
inlaid by Italian craftsmen with specimen stones from England,
and features the insignia of the Order of the Garter.

The throne dais that had stood at one end of St George's Hall was removed, creating a clear view and processional route through the Hall. The Hall itself was reconstructed, the hammerbeam roof in green oak with a modern lighting scheme hidden in the armours and ceiling bosses, and space for camera facilities used to record state occasions. The restoration work revealed aspects of the Castle's history, such as the long-hidden Norman arches near the Glass Pantry, and enabled the floor of the Great Kitchen to be replaced with Purbeck marble as it had been during the reign of Elizabeth I.

LEFT: The Grand Reception Room, Windsor Castle, after the fire

RIGHT: The new private chapel, Windsor Castle

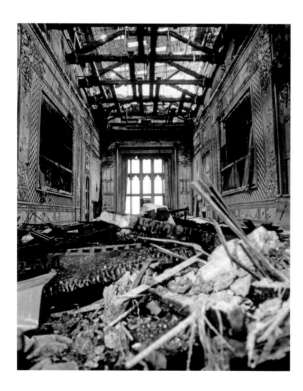

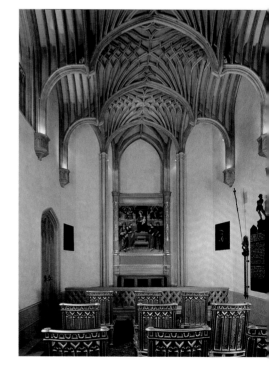

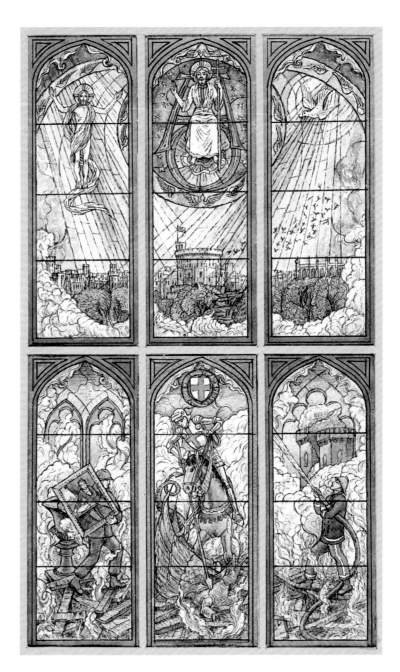

Prince Philip was involved in the design for this stained-glass window at the west end of the new private chapel. This is one of the preliminary designs by the artist Joseph Nuttgens. It commemorates the fire, the effort to rescue the works of art and the Castle's restoration

Restoration, a detailed account of the fire and its aftermath by Adam Nicolson, was published in 1997. This copy, with a special binding designed and made in the Royal Bindery, is kept in the Royal Library at Windsor Castle

The restoration was completed in November 1997, when a reception for The Queen and Prince Philip's Golden Wedding anniversary was held at the Castle on the fifth anniversary of the fire. The site where the fire originated is marked with a commemorative monument.

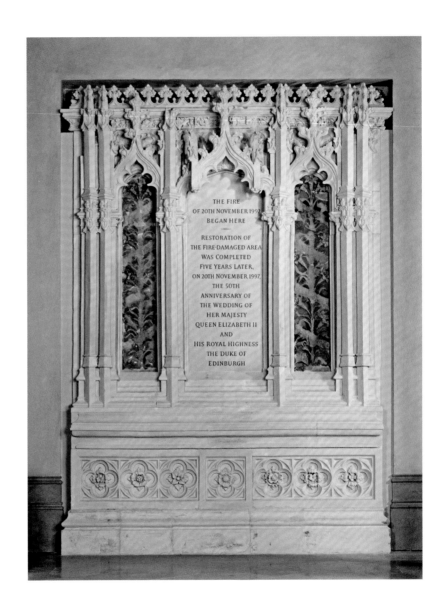

THE FIRE
OF 20TH NOVEMBER 1992
BEGAN HERE

—

RESTORATION OF
THE FIRE-DAMAGED AREA
WAS COMPLETED
FIVE YEARS LATER,
ON 20TH NOVEMBER 1997,
THE 50TH
ANNIVERSARY OF
THE WEDDING OF
HER MAJESTY
QUEEN ELIZABETH II
AND
HIS ROYAL HIGHNESS
THE DUKE OF
EDINBURGH

ABOVE: The monument commemorating
the fire and restoration

OPPOSITE: The Lantern Lobby, Windsor Castle,
on the site of the former private chapel

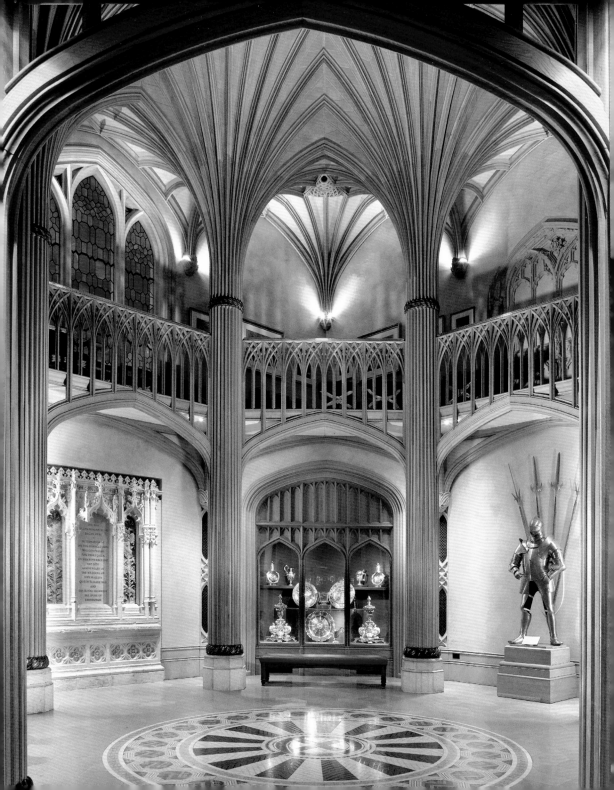

STATE VISITS AND INTERNATIONAL TRAVEL

INTERNATIONAL TOURS, undertaken at the request of the
UK government, enable the Royal Family to support British
interests abroad and pursue engagements relating to their own
patronages. In 1956–7 Prince Philip travelled 23,000 miles in
HMY *Britannia* and 15,000 miles by air on a trip that included
Kenya, the Seychelles, Ceylon (now Sri Lanka), Malaysia,
New Guinea (now Papua New Guinea), Australia (including
Norfolk Island), New Zealand (including the Chatham Islands),
Antarctica and The Gambia. In the Atlantic, the British Overseas
Territories of the South Shetland Islands, the Falkland Islands,
South Georgia, Gough Island, Tristan da Cunha, St Helena and
the Ascension Islands were visited for the first time by a senior
member of the Royal Family. Among those accompanying
Prince Philip on board *Britannia* was the artist Edward Seago.

Prince Philip broadcast a brief Christmas Day message while
sailing between New Zealand and Cape Horn; in The Queen's

TOP: Prince Philip points out trout in
the stream to Princess Elizabeth at
Sagana Lodge, Kenya. The royal couple
were at the start of a Commonwealth
tour when news of King George VI's
death at Sandringham House on
6 February 1952 reached them in Kenya

LEFT: In Ottawa in 1951 the royal
couple attended a square dance,
Prince Philip wearing jeans, checked
shirt and suede loafers

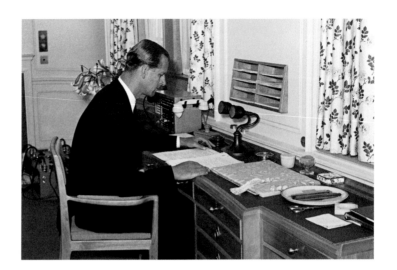

Prince Philip broadcasting his Christmas Day message while on royal tour aboard HMY *Britannia* in 1956

Christmas Broadcast that followed, she spoke of his absence: 'If my husband cannot be at home on Christmas Day, I could not wish for a better reason than that he should be travelling in other parts of the Commonwealth.' The next day the first iceberg was sighted. Taking advantage of his voyage to the southern hemisphere, Prince Philip attended the Antarctic Symposium in Melbourne. At Lyttelton in New Zealand he met the explorer and conqueror of Everest, Sir Edmund Hillary, and toured the Commonwealth Trans-Antarctic Expedition ship *Endeavour*. The crew of *Britannia* received 'Red Nose' certificates to celebrate crossing the Antarctic Circle; veteran sailors who had done so before were given a 'Purple Nose'. The certificates were designed by Seago, and Prince Philip assisted with the inking and printing.

Gibraltar was the last point on the itinerary before the Prince joined The Queen at Lisbon airport for the State Visit to Portugal. Despite the remoteness of much of the tour,

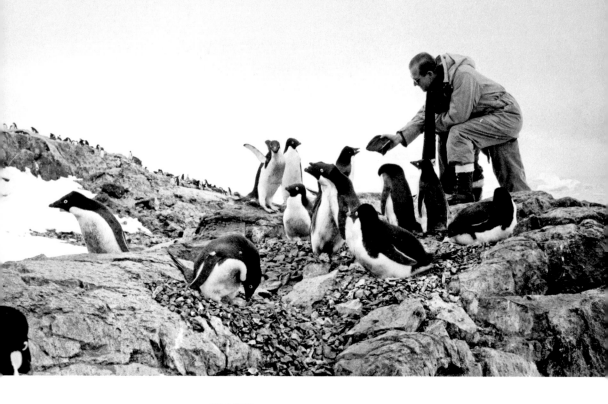

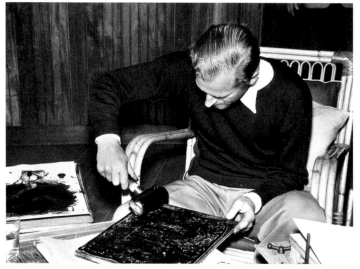

ABOVE: Prince Philip befriends penguins in the Antarctic in 1957, during his tour in *Britannia*

RIGHT: Prince Philip takes his turn with an inked roller to produce 'Red Nose' certificates that were awarded to HMY *Britannia*'s crew for crossing the Antarctic Circle, 1956

more than 1,400 guests had been entertained in *Britannia* as part of reciprocal events in the various places visited.

On his return to the United Kingdom, Prince Philip gave an illustrated talk about his tour to 2,000 schoolchildren at the Royal Festival Hall in London, and was also welcomed back by a banquet hosted by the Lord Mayor of London at Mansion House. In his speech the Prince spoke of his commitment to the Commonwealth:

> I believe that there are some things for which it is worthwhile making some personal sacrifice,

Prince Philip is greeted by cheering children at Waipukurau, during the tour of New Zealand by The Queen and Prince Philip in 1953

and I believe the British Commonwealth is one
of those things, and I, for one, am prepared to
sacrifice a good deal if by so doing, I can advance
its well-being by even a small degree.

New orders of chivalry have been introduced in several
Commonwealth countries during The Queen's reign.
Prince Philip's service to The Queen and his own support
of the Commonwealth were recognised by the receipt
of several of these orders, including the Member First Class
of the Order of the Brilliant Star of Zanzibar and an Extra
Companion of The Queen's Service Order of New Zealand.

Prince Philip was closely identified with a number of
Commonwealth organisations, including the Commonwealth
Games Federation (President 1955–90) and the Royal
Commonwealth Ex-Services League, of which he was Grand
President from 1964 until 2015.

Great public interest is often shown in royal visitors.
During the Coronation tour of Australia in 1954 an estimated
seven million people saw The Queen and Prince Philip,
and one million Ghanaians lined the route of a single drive
through Accra in 1999. The Kastom people who live around
Yaohnanen village on the island of Tanna in Vanuatu revered
Prince Philip in his lifetime as the 'pale-skinned son of a
mountain god' who features in their legends, and celebrated
the Prince's birthday each year.

During a tour or official engagement, gifts are often
exchanged to mark the occasion. Such gifts might be seen or
worn at future events. Prince Philip also occasionally presented
gifts, such as a battery-powered phonograph and a small

Prince Philip was awarded the
Order of the Brilliant Star of
Zanzibar (now part of Tanzania)
in 1963

collection of records to the island of Tristan da Cunha in 1957. After learning that the researchers stationed at the British Antarctic Survey had finished all their reading material, Prince Philip sent a crate of new books to them.

Some official gifts received by the Royal Family are placed on long-term loan with relevant national institutions, such as the British Museum. Others are placed on display in the royal residences.

Prince Philip's tour of South America in 1962 was notable for the support it gave British trade with the continent, and for the extensive itinerary encompassing several countries that had never before received a visit from the British Royal Family.

On occasion, Prince Philip would make visits in support of The Queen before her own official duties or diplomatic sensitivities allowed her to do so. He visited British armed forces stationed in the Rhineland in March 1953, some 12 years

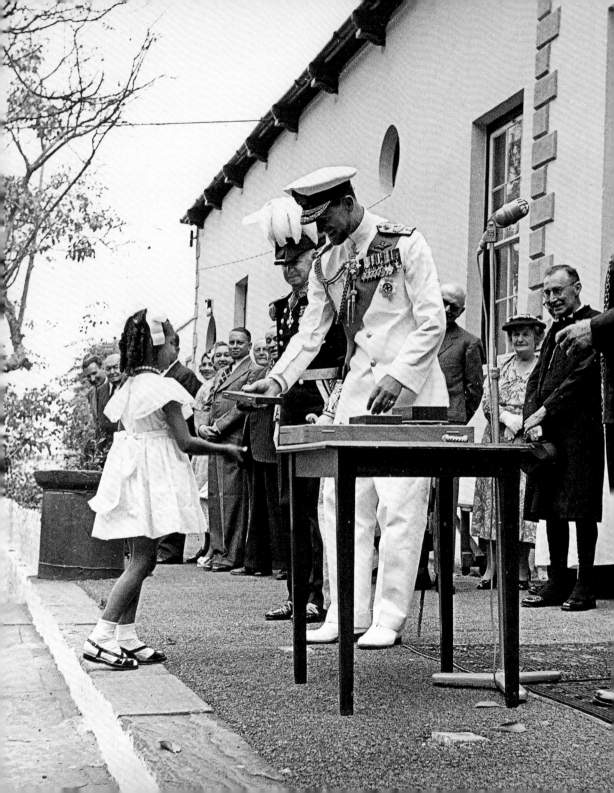

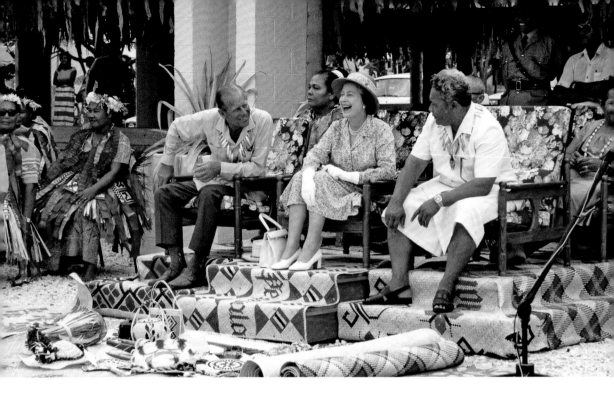

Prince Philip and The Queen
in Funafuti, Tuvalu, with the
Prime Minister of Tuvalu,
Dr Tomasi Puapua, during the
royal tour of the Pacific, 1982

before The Queen first travelled to the Federal Republic of
Germany. In 1973 he went to the Soviet Union in support of the
Fédération Equestre Internationale, which sets international
rules for the equestrian sports in the Olympics. In 1993
The Queen and Prince Philip made their first official visit to a
former Eastern bloc country with a four-day tour of Hungary.
During overseas visits with The Queen, Prince Philip also
undertook solo engagements. In 1972, during the State Visit
to France, the Prince lunched with the Paris Chamber of
Commerce while The Queen was at the British Embassy, and
he travelled to the Camargue nature reserve while The Queen
toured Avignon. During the 1953–4 tour of New Zealand with
The Queen, Prince Philip visited Wellington to lay a wreath near
the site of the Tangiwai train disaster on behalf of The Queen.

On 10 May 1994 Prince Philip represented The Queen at the inauguration of Nelson Mandela as President of South Africa. Following Mandela's election, the country rejoined the Commonwealth, and in March 1995 The Queen and Prince Philip paid a historic visit to the country.

Other members of the Royal Family sometimes accompanied Prince Philip on official engagements and tours. With her father, Princess Anne attended the Shah of Iran's celebration of 2,500 years of the Persian empire in 1971. Prince Charles and Princess Anne joined both their parents for the 1977 Silver Jubilee tour of Australia, New Zealand and several Pacific island nations.

The Queen and Prince Philip wave to spectators on Parliament Hill, Ottawa, during a tour of Canada, 1967

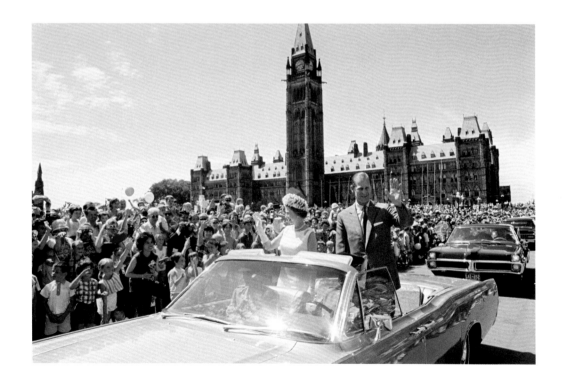

ENCOURAGING
FUTURE
GENERATIONS

THE NUMBER of associations, organisations and charities with which Prince Philip became involved increased greatly after the accession of The Queen. He was particularly drawn to the education of young people, especially relating to sport, outdoor pursuits and adventurous activities. This led to his best-known contribution to youth achievement, the Duke of Edinburgh's Award.

Prince Philip's first solo engagement as Duke of Edinburgh reflected this interest. At the Royal Albert Hall in March 1948 he presented the prizes at the boxing finals of the London Federation of Boys' Clubs (now London Youth). The organisation was originally set up to help underprivileged boys in London, notably in the East End. The Prince had become Patron in 1947, his first charity patronage, and he remained involved for more than 70 years.

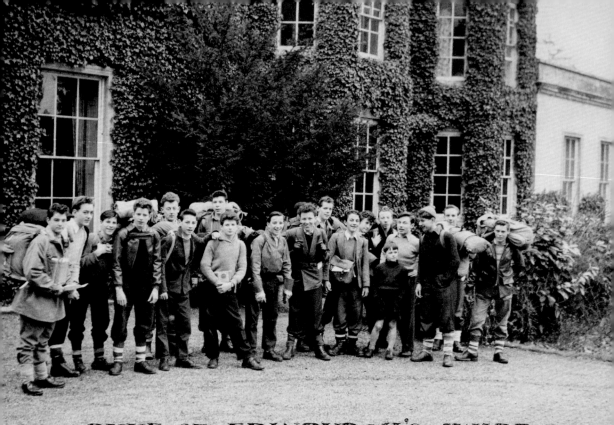

DUKE OF EDINBURGH'S AWARD
FIRST EXPEDITION TEST. FEB. 1ˢᵗ~3ʳᵈ 1957

Participants in the first Duke of Edinburgh's Award expedition, photographed at Woodrow High House, Buckinghamshire, 1957

Concerned about the lack of open-air facilities for young people to use for recreation and sport, Prince Philip became President of the National Playing Fields Association (now Fields in Trust) in 1947, which had been set up in 1925 by the future King George VI to protect parks and green spaces in urban areas. Prince Philip was involved in every aspect of the organisation until 2013, when he was succeeded by his grandson, The Duke of Cambridge.

In 1953 Prince Philip became Patron of the Outward Bound Trust, a network of organisations that aims to foster personal growth and social skills through participation in outdoor expeditions. One of the founders in 1941 was Prince Philip's former headmaster at Gordonstoun, Kurt Hahn. In 2019, the mountaineer Sir Chris Bonington noted the Prince's 'enduring and unflappable commitment to changing the lives of so many young people through outdoor adventurous learning'.

The Duke of Edinburgh's Award

In 1956 Prince Philip co-founded the Duke of Edinburgh's Award. It is now the world's leading youth achievement award. After the war Dr Hahn asked the Prince to become involved in a national programme to support young people's development. Prince Philip thought this was an ideal way in which to make a positive contribution to youth issues and agreed to steer the project as Patron.

A Duke of Edinburgh's Award Gold Badge, which features the double P design, the emblem of the award

At first the objective of the award was to motivate young boys between the ages of 15 and 18 to take on a balanced programme of self-development activities. Prince Philip said: 'it is designed to show how you can spend your leisure time, how you can help your fellow citizens and, above all, what you can achieve if you set your mind to it'.

In the first 12 months 4,000 boys enrolled in the pilot scheme. The age limit was soon lowered to 14 and in 1958 a pilot scheme for girls was launched. In 1959 the Duke of Edinburgh's Award became a charitable trust and was set up with a formal constitution, with Prince Philip as Chairman.

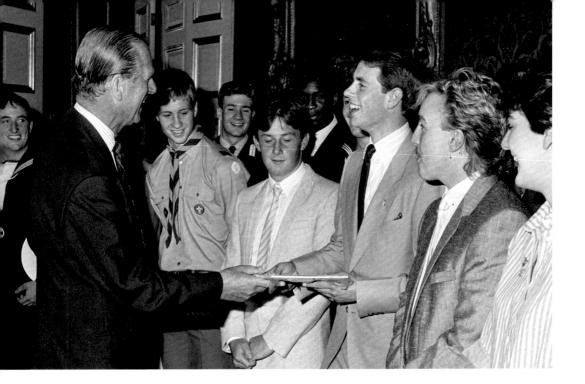

ABOVE: Prince Philip presents his son, Prince Edward, with his Gold Award at St James's Palace, 1986

BELOW: An Isle of Man Proof Crown, commemorating the 25th Anniversary of the Duke of Edinburgh's Award in 1981

The award, known informally as the 'DofE', has Bronze, Silver and Gold levels. All three involve helping the community or environment, physical fitness, developing new skills and undertaking an expedition. The first Gold Awards for boys were achieved in 1958 and for girls in 1959. By 1980 the separate boys and girls awards had been integrated, and the age extended to 24. An allied programme was also developed for young people with disabilities.

Prince Philip remained Chairman of the award until 2001 and Patron until his death. The Prince regularly presented Gold Awards to recipients at Buckingham Palace and St James's Palace in London, the Palace of Holyroodhouse in Edinburgh and Hillsborough Castle in Northern Ireland. In the year 2019/20 more than 159,000 awards were achieved.

Shortly after its foundation, news of the award spread throughout the Commonwealth, and Canada, Australia and New Zealand soon initiated their own versions. Others followed, including the United States of America and countries in south-east Asia, Africa and the West Indies. The unique structure and composition allowed the award to be adapted and integrated into many different cultures and societies with

Prince Philip meets cyclists who are about to embark upon a sponsored ride from Buckingham Palace to Windsor Castle for a Duke of Edinburgh's Award fundraising event, 1975

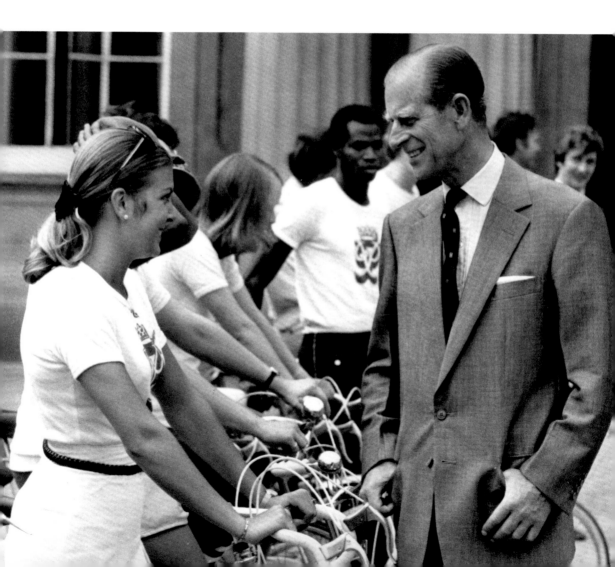

relative ease. The Duke of Edinburgh's International Award Foundation now helps to inspire millions of young people in more than 140 countries.

In 2016 a Service of Thanksgiving to mark 60 years since the foundation of the award was held at Westminster Abbey. The Earl of Wessex, who had been a Trustee for many years and Chairman of the International Council, spoke of his father's contribution: 'they [the participants] all know, whether they come from a travellers' community, a Jewish community, a Muslim community, a Maori community, a Kenyan slum,

In 2016 the award celebrated its Diamond Anniversary and a Diamond Challenge was announced. The Countess of Wessex completed a 450-mile charity bicycle ride between the Palace of Holyroodhouse and Buckingham Palace, raising more than £100,000

South African prison, Ghanaian hospital, Ireland, Scotland,
Wales or England that this award bears your name, that you
started it and you did it because you have faith in people'.
In 2017 The Earl of Wessex took over much of his father's
involvement with the award.

Prince Philip with award
recipients from its eight
decades of activity ahead
of a reception to celebrate
the 500th Gold Award
presentation at St James's
Palace in 2013

Education

Through his patronages Prince Philip was associated with several schools, colleges and universities. He was Chancellor of four universities, with his earliest appointment being that of Chancellor of the University of Wales in 1948. At his installation in Bangor, north Wales, he presented an honorary degree to Princess Elizabeth. He served in that role until 1976.

In 1953 Prince Philip was appointed Chancellor of the University of Edinburgh, a position he occupied for nearly 60 years. At his installation ceremony he commended the university for its 'vigour and vitality' and confirmed his passionate belief in the positive benefits of education. Throughout his chancellorship he promoted the work of the university and provided encouragement to students and staff. He showed a particular fascination for scientific study and the results of

Prince Philip is presented with a silver paperweight by Pete the Robot at the University of Salford, 1989

research and investigation. He conferred numerous honorary degrees and formally opened many university buildings. He retired from the role in 2010 and was succeeded by his daughter, The Princess Royal.

Prince Philip was installed as Chancellor of the University of Cambridge in 1977. When he retired from the role after 34 years, the Vice-Chancellor, Professor Leszek Borysiewicz, paid tribute: 'there is hardly a corner of the university and its colleges he has not visited, always showing the keenest interest in our students, our teaching and our research'.

Prince Philip was also appointed the first Chancellor of the University of Salford in 1967. Formed from a merger of technical colleges and institutes, it focuses on industry-based research. The Prince retired from the post in 1991.

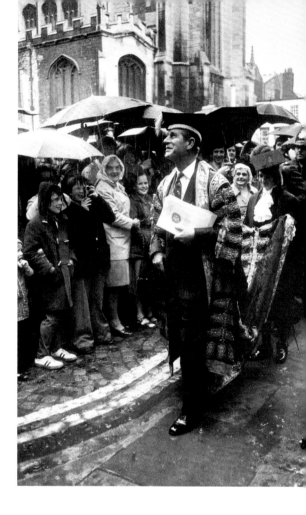

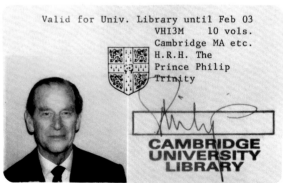

ABOVE: Prince Philip walks through the streets of Cambridge wearing academic robes and mortar board following his installation as Chancellor of the University of Cambridge, 1977

LEFT: Prince Philip's University of Cambridge library card

SCIENCE AND
INDUSTRY

ONE OF PRINCE PHILIP'S earliest public speeches was the
Presidential Address he gave at the British Association
for the Advancement of Science (now the British Science
Association) in 1951. It included a message from King George VI
and opened with excerpts from a speech given by Prince Albert,
Prince Philip's great-great-grandfather, upon being invited to
be President of the same association in 1859. Prince Philip
paid tribute to the improvements in science over the preceding
century, urging its employment for the benefit of mankind.
The audience of more than 2,000 was matched by the number
who tuned in to watch on television.

In 1956 Prince Philip founded the Commonwealth Study
Conferences for Science and Industry, which examine
the modern human aspects of industrialisation across the
Commonwealth. The idea resulted from the Prince's visit to
Canada in 1954 when he saw new industries in the north of

the country. The first conference was held in Oxford, with breakaway periods spent in industrial cities such as Liverpool and Glasgow; one-third of the delegates were from Britain and the other two-thirds from the Commonwealth. The Princess Royal subsequently took on the patronage of the conferences in 2011, and these continue to be held every six years in a Commonwealth member country.

In 1961 Prince Philip was the first member of the Royal Family to give a television interview when he was asked by

Prince Philip speaking at the British Association for the Advancement of Science, Edinburgh, 1951

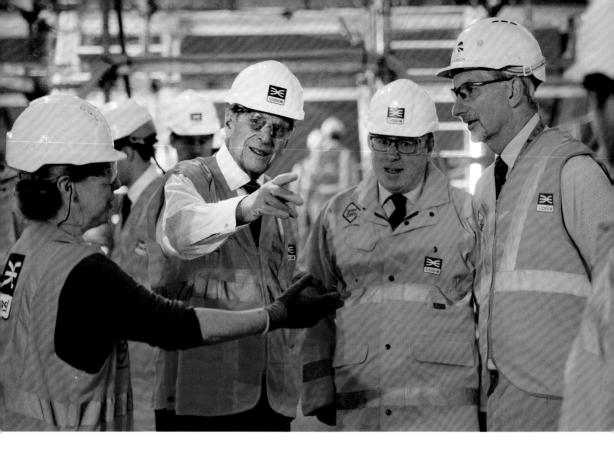

Prince Philip meeting some of the apprentices, construction workers and engineers delivering the new Crossrail station under construction 30 metres below Farringdon in London, 2015

Richard Dimbleby to launch the first Commonwealth Technical Training Week. This aimed to encourage young people into technical training at the start of their careers.

The Royal Microscopical Society invited Prince Philip to be its President in 1966, its centenary year, during which he was presented with a microscope that had belonged to the Victorian metallurgist John Perry.

Prince Philip's support of science also extended to the field of medicine. He was appointed Patron of the Royal College of Surgeons of Edinburgh in 1955. His inaugural speech toasted the craft of surgery and he assured the listeners

that he was not tempted to follow the example of James IV of Scotland who reputedly performed medical procedures on members of his household. The Prince's final engagement as Chancellor of the University of Edinburgh was at its Clinical Research Imaging Centre in 2010.

Speaking on BBC Radio 4's *Today* programme in 2016, Prince Philip highlighted the vital importance of engineering: 'Everything that wasn't invented by God is invented by an engineer'. In 1965 he became President of the newly formed Council of Engineering Institutions, and four years later he was appointed Colonel-in-Chief of the Corps of Royal

Visiting Wavertree Technology Park, Liverpool, 1987

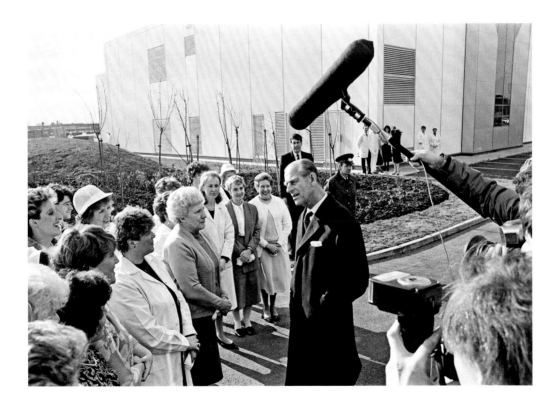

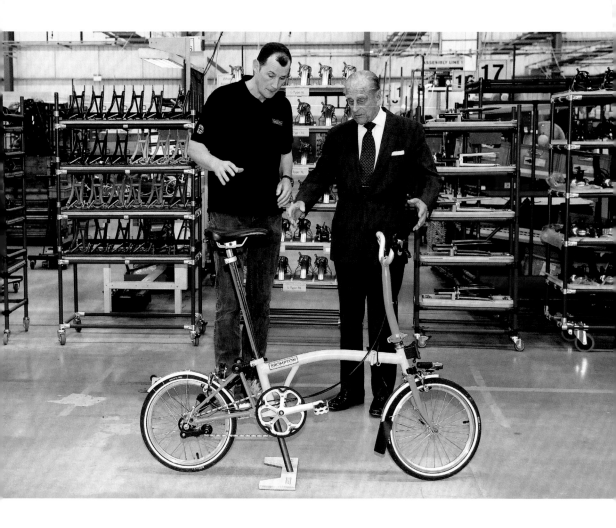

Prince Philip is shown a Brompton bicycle by the company's CEO, Will Butler-Adams, as he opens their new factory in 2016. The folding bicycle won the Prince Philip Designers Prize in 1999

Electrical and Mechanical Engineers. In 1976, at Prince Philip's suggestion, the Fellowship of Engineering at the Royal Academy of Engineering was established to create a body for distinguished engineers and the Prince was appointed a Senior Fellow.

Prince Philip attended the Festival of Britain held in London in 1951 to celebrate post-war industry and design. He has

notably championed design through the founding of prizes, his patronages and several personal commissions.

At the accession, Prince Philip was invited to join the Royal Mint Advisory Committee as President. This committee was tasked with designing the coinage for the new reign and with oversight of the new design for the Great Seal, used on official and legal documents. The Prince remained on the committee until 1999.

The Duke of Edinburgh's Prize for Elegant Design (now the Prince Philip Designers Prize) has been awarded annually since 1959 to a contemporary designer whose product is distinctively elegant. The Prince was Chair of the judging panel, which sought to recognise classic, functional modern design. In 1966 the prize was presented for the first time for handmade craft pieces, rather than industrially made products, to the jeweller Andrew Grima. His designs were notable for their free handling of texture, particularly in gold, and his innovative choice of stones. Grima's prizewinning range of jewellery included brooches, rings, bracelets and a tiara. In 1981 the prize was presented to a somewhat larger object, the newly launched Austin Mini Metro car designed by British Leyland, described by the President of the British Design Council as 'evidence of intelligent, realistic and basic design in every part of the product'.

In 1968 the Prince inaugurated the Prince Philip Prize for Australian Design, attending the first awards ceremony in Sydney that year, which coincided with the third Commonwealth Study Conference. The first winner was David Shearer Ltd for its XP88 Self Propelled Header, used for crop harvesting. Each prizewinner had to produce an

original Australian design closely associated with Australian life
and industry and able to contribute to the Australian economy.
A similar prize was also sponsored in New Zealand.

The Prince supported British invention and design with
the Prince Philip Medal awarded to individuals, initially those
under the age of 40 who held a qualification through the City
and Guilds of London Institute. The first winner was 35-year-
old John West, a naval architect and designer whose work
included the P&O liner SS *Canberra*, launched in 1960. The
silversmith Jocelyn Burton became the first woman to be
awarded this medal, in 2003.

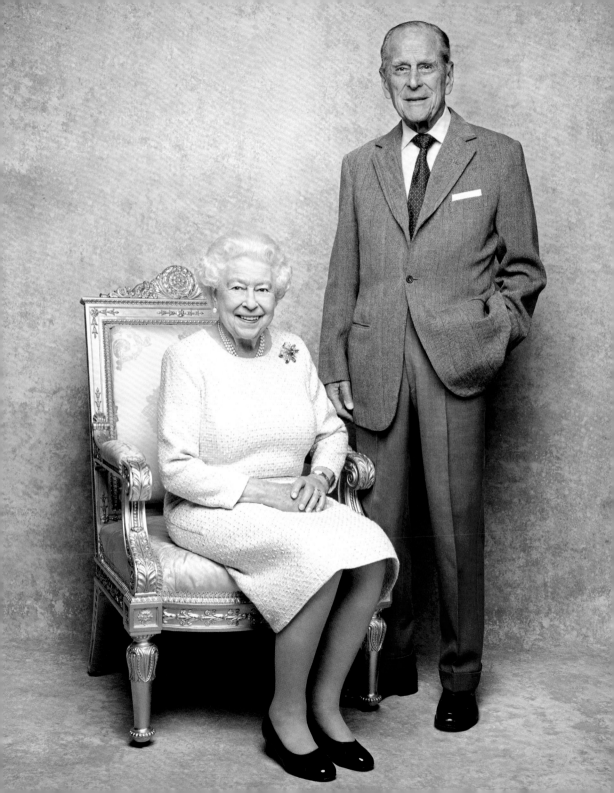

CONSERVATION AND
THE ENVIRONMENT

P RINCE PHILIP became Ranger of the 5,000-acre Windsor
Great Park in 1952 and was the longest serving Ranger
since the position was created in 1601. During his 69 years as
Ranger, he oversaw significant changes across the estate, which
now attracts almost 5 million visitors each year to walk, cycle,
ride or run, or visit the Savill and Valley Gardens. Avenues of
trees have been renewed according to their life cycles or after
damage such as that suffered during the 1987 storm. Queen
Anne's Ride was replanted with 1,000 oak trees in 1992–3,
to celebrate the 1,000th anniversary of the founding of the
office of High Sheriff. In 1980, the Prince said, 'I feel that I am a
temporary custodian, that I am planting for future generations'.

One of the most popular sights in the Great Park is the
600-strong herd of red deer, reintroduced by Prince Philip in
1979 using animals from the Balmoral estate. The wider estate
also includes working farms and the Windsor Farm Shop,
which provides a commercial outlet for produce from the
Royal Estates and local suppliers.

OPPOSITE: Prince Philip stands
near the oversize statue of
George III, known as the
Copper Horse, Windsor
Great Park, 1996

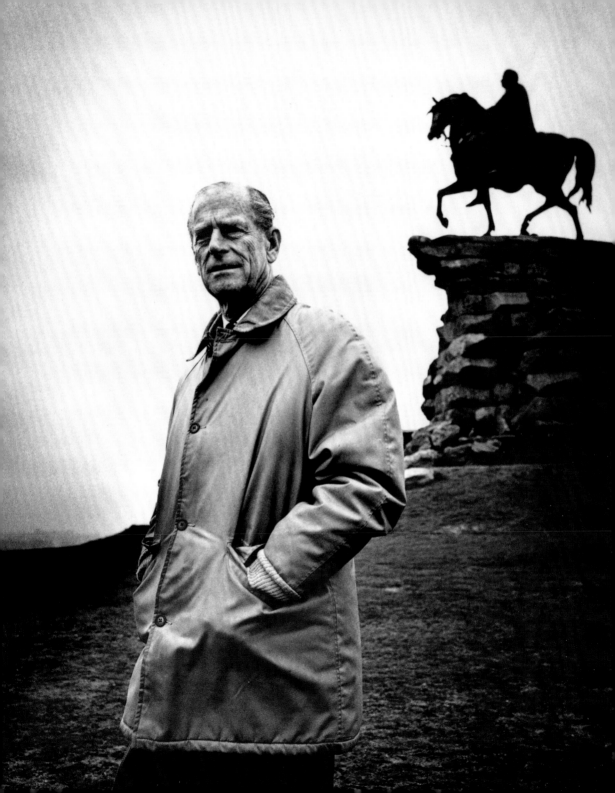

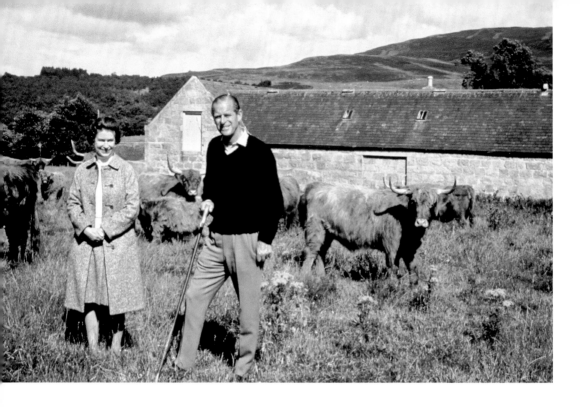

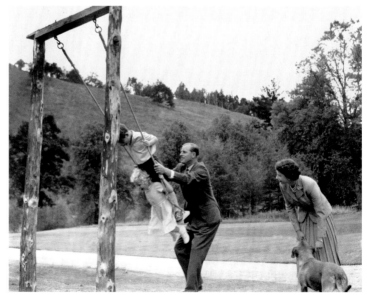

ABOVE: The Queen and
Prince Philip on the
Balmoral estate, 1972

RIGHT: Prince Philip pushes
Prince Charles and Princess
Anne on a swing in the grounds
of Balmoral Castle, 1955

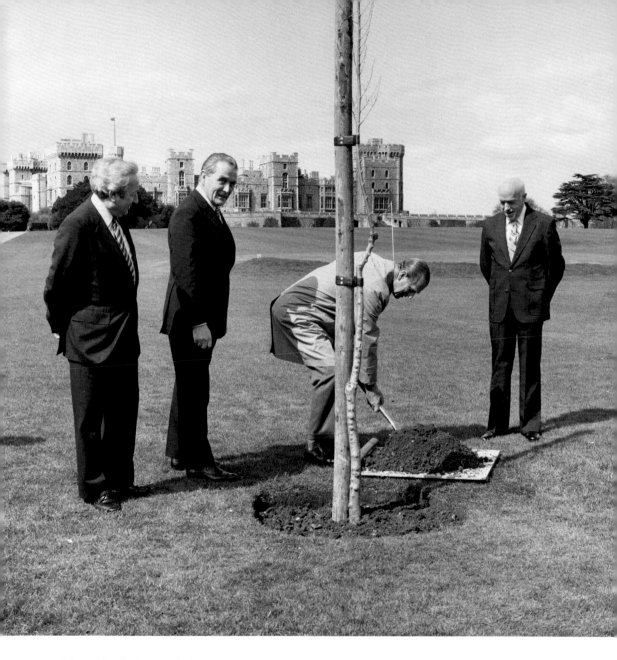

Prince Philip planting a Dutch elm
disease-resistant variety of elm close
to Windsor Castle, 1980

After the Accession, Prince Philip took on the management of the Balmoral and Sandringham estates. The Prince of Wales subsequently took over the latter estate from his father in 2015, where responsibilities include eight tenanted farms comprising 10,000 acres plus 3,500 acres of woodland and 200 acres of orchards and soft fruit cultivation, and a number of village properties and business premises.

Prince Philip championed the allocation of land to wildlife conservation, particularly the extension of field margins as habitats for ground-nesting birds and the creation of ten wetland habitats. More than two million trees and 40 kilometres of new hedge have been planted, reversing changes made across East Anglia with the intensification of farming. Sandringham House opened to the public for the first time in 1977, including a small museum, which houses gifts and works of art presented to the Royal Family.

In 1957 Prince Philip founded the Royal Agricultural Society of the Commonwealth, and remained Patron until his death. This is the only non-governmental Commonwealth organisation representing agriculture and it was established to improve crop production and livestock breeding as well as to work collectively towards livestock regulation. The society also encourages exchanges of agricultural workers, new farmers and students.

Sir David Attenborough said of Prince Philip in 2021, 'he was right there at the beginning at a time when conservation didn't mean much to many people'. Prince Philip became involved with the World Wide Fund for Nature (WWF) at an early stage in its development. In 1961 ornithologist and conservationist Peter Scott was working to set up an international charity to prevent further extinctions and encourage the education

Prince Philip with Peter Scott at his nature reserve in Slimbridge, Gloucestershire, in 1963, where several trumpeter swans presented to The Queen in Canada in 1951 had been rehomed

of young people in conservation and animal protection. The Prince agreed to become the President of the UK branch. By the end of 1961 the WWF had allocated money to curb rhino-horn poaching, extend Ngurdoto Crater National Park (now Arusha National Park) in Tanzania and send students to Tristan da Cunha to assist with the establishment of a nature reserve. Prince Philip served as President of the UK branch until 1982 but continued as President of WWF International until 1996.

His work as Patron of the British Trust for Ornithology (BTO) focused on birds in Britain, contributing to global data on bird populations. Many of Prince Philip's solo tours and

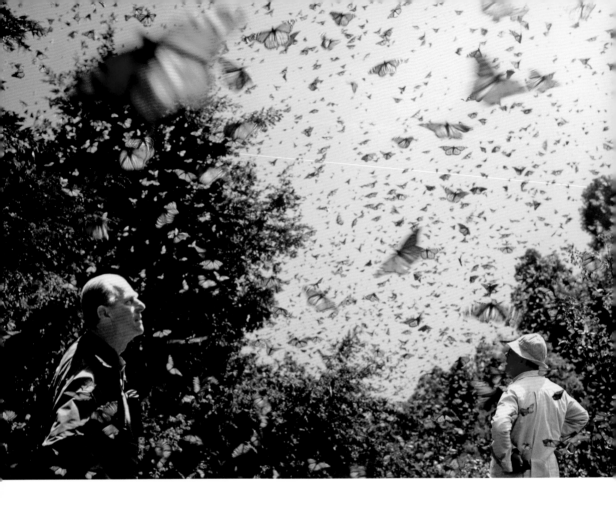

In 1988, during an official visit to Mexico, Prince Philip visited the Sierra Chincua reserve and witnessed the migration of the monarch butterfly. The Prince had previously remarked, 'words alone cannot hope to convey the extraordinary nature of the monarch's life cycle'

engagements from the 1960s onwards related to his work with the WWF, the BTO and the Zoological Society of London, of which he was President from 1960 to 1977 and subsequently an Honorary Fellow.

The Prince was also committed to the wellbeing of local communities. In 1977 the grant-giving Prince Philip Trust Fund was established to support the residents of the Royal Borough of Windsor and Maidenhead. Under the Prince's chairmanship and through fundraising activities such as car rallies on the

LEFT: Prince Philip visits a panda sanctuary during the State Visit to China in 1986

ABOVE: This watercolour of a noisy scrub-bird was presented to Prince Philip by the Premier of Western Australia in 1990. In 1961 the Prince had written to a previous Premier to comment on the allocation of land for building that included the habitat of the endangered bird. The development was moved and the site is now a nature reserve, where the birds today number approximately 600

Long Walk of the Great Park, the fund grew considerably. By 2020 it had given out over £2,000,000 in grants to more than 1,600 projects and good causes, helping children and young people, those in social need, the elderly and people living with disabilities, as well as supporting the local arts scene and improving access to sports. The Earl of Wessex has since taken over the chairmanship and an additional £100,000 was distributed during 2020 to assist the local community during the Covid-19 pandemic.

SPORTING
INTERESTS

P RINCE PHILIP enjoyed a variety of sporting interests from a young age, particularly during his time at Gordonstoun. In 1949 Prince Philip recalled how his earliest instruction in sailing 'stood me in good stead during the years of the war'. Himself a capable sportsman, the Prince's patronages often reflected his own sporting pursuits, the support of young people becoming involved in new sports, and the governing bodies behind events such as the Olympic and Commonwealth Games and the Fédération Equestre Internationale (FEI).

Equestrian

Prince Philip learned to ride horses as a young boy and his earliest equestrian memories were of riding at the beach near Constanța on the Black Sea with his young cousin Michael, King of Romania.

OPPOSITE: Prince Philip at a polo match, 1966

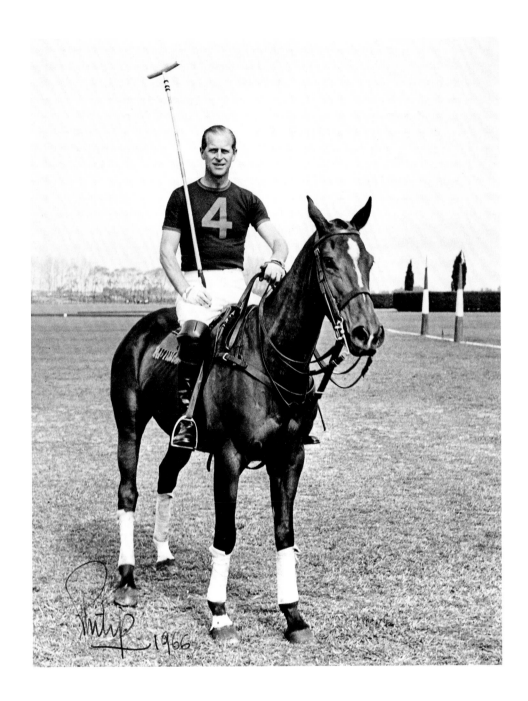

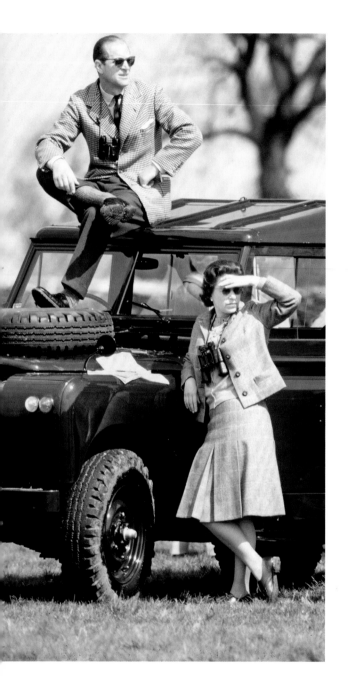

While resident in Malta between 1949 and 1951, Prince Philip was introduced to polo, which he played regularly at Cowdray in Sussex and at a new ground he founded in Windsor Great Park, called the Guards Polo Club.

Prince Philip was elected President of the FEI in 1964, being re-elected five further times and retiring in 1986. The FEI sets international rules for dressage, showjumping and three-day eventing in the Olympics. During Prince Philip's tenure as President he was approached to rewrite the rules for international carriage driving, which was then especially popular in continental Europe. This introduced him to a new sport following his retirement from polo in 1971, the year of his fiftieth birthday. Rules for carriage-driving competitions in cross-country and obstacle driving were established to echo those of ridden three-day eventing, and the Prince was instrumental in devising a scoring system for presentation of the teams, including the horses,

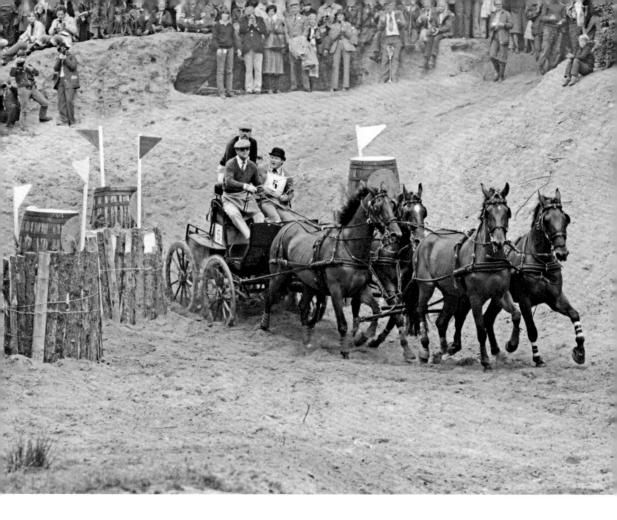

carriages, drivers and grooms. Prince Philip also instigated the use of specially designed cones as course markers, with balls balanced on top; penalties were accumulated if the balls fell when knocked by a horse or carriage.

Royal Windsor Horse Show first featured a carriage-driving competition under FEI rules in 1972 and it is now the longest-running international carriage-driving competition. Prince Philip competed regularly in the United Kingdom and Europe.

ABOVE: Prince Philip negotiates the sandpit during an obstacle course at the World Carriage Driving Championships at Windsor, 1980

OPPOSITE: Prince Philip and The Queen at an equestrian event, 1968

Sailing

Prince Philip learned to sail in Gordonstoun's schooner *Prince Louis* and sailed to Norway in the fishing smack *Henrietta* in 1937. The Prince first attended Cowes Week, the annual sailing regatta held in the Solent, the channel separating Hampshire from the Isle of Wight, in August 1948. Following the Prince's first meeting with Uffa Fox, the legendary Cowes-based yacht designer, Fox presented the Prince with a wedding gift, *Coweslip*, which he had designed. *Coweslip* was joined in royal ownership by two other Fox-designed yachts, both of them wedding presents: *Kiwi*, from the Royal New Zealand Navy, and the Dragon-class *Bluebottle*, from the Island Sailing Club at Cowes.

Coweslip was retired in 1961 and Prince Philip acquired the 63-ft 1930s racing yacht *Bloodhound*. He enjoyed sailing *Bloodhound* during private family holidays each summer, when her crew would bring the yacht to meet HMY *Britannia* in the Western Isles of Scotland.

Prince Philip served as Admiral of the Royal Yacht Squadron from 1948, becoming Commodore for six years in the 1960s. During this time he oversaw reforms designed to modernise the squadron.

COWESLIP

BEKEN & SON
COWES

Since its foundation in 1514, Prince Philip was the longest-serving Master of Trinity House, a charity dedicated to safeguarding shipping and seafarers. In 2011 The Princess Royal, herself a keen yachtswoman, succeeded her father as Master.

Prince Philip was a Trustee of the National Maritime Museum from 1948 to 2000, when he was appointed its Patron. He oversaw the modernisation of the museum in the late 1950s and the Prince Philip Maritime Collections Centre was named after him. He co-founded the Cutty Sark Preservation Society in 1953, and was instrumental in establishing the ship's permanent berth in Greenwich.

LEFT: Sailing *Coweslip* at Cowes, c.1960. *Coweslip*, a 15-ft two-person Flying Fifteen keelboat, was frequently crewed by Prince Philip and Uffa Fox, including in Malta when the Prince was stationed there

RIGHT: Prince Philip and Princess Anne at Cowes, 1970. Prince Charles and Princess Anne both learned to sail on *Bloodhound*

Flying

BELOW: The photograph issued
to the press to mark Prince
Philip gaining his wings, 1953.
The Prince's training operation
under the RAF pilot instructors
was codenamed Thrush, and his
codename was Rainbow

OPPOSITE: Prince Philip flying
solo over Windsor Castle, 1953

Soon after The Queen's accession, Prince Philip indicated his interest in learning to fly, both to show his support for military and civilian flying and as a potential form of regular and efficient transport. When Princess Elizabeth and Prince Philip paid an official visit to Canada in 1951 they became the first members of the Royal Family to fly over the Atlantic. The Prince had his first aeroplane instruction in November 1952 at RAF White Waltham, close to Windsor Castle, and his first solo flight was the following month. He gained his helicopter wings in 1956 and his private pilot's licence in 1959. Between 1952 and

1997, when Prince Philip relinquished his licence, he logged 5,986 flying hours in 53 types of fixed-wing aircraft, including a test flight of Concorde, and 12 types of helicopter.

Prince Philip piloted a de Havilland Dove aircraft of The Queen's Flight to engagements in the 1950s and co-piloted 49 of the 62 internal flights on a Herald during his 1962 tour of South America.

He also learned to fly helicopters in the 1950s, then a relatively new form of air transport. The Prince was appointed Grand Master of the Guild of Air Pilots and Air Navigators in 1953 and through them inaugurated the Prince Philip Prize for Helicopter Rescue.

Cricket

Prince Philip was a talented cricketer and a keen fan with a long association with the sport. When he and Princess Elizabeth moved to Windlesham Moor shortly after their marriage, he set up stumps in the grounds and practised regularly. Many of the matches in which the Prince took part were played to raise funds for charity, in particular the National Playing Fields Association.

A frequent spectator of cricket, Prince Philip was the first member of the Royal Family to serve as President of the

Prince Philip bowling at a cricket match at the Petty Officers' Training School, Corsham, Wiltshire, 1947. He had previously captained the First XI at Gordonstoun

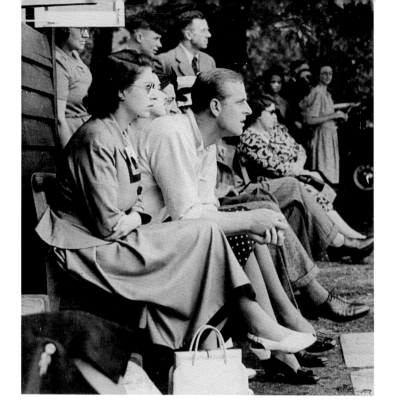

Princess Elizabeth and Prince Philip watching a cricket match at Windsor Castle in 1948. Prince Philip had played but was caught in the slips for seven

Marylebone Cricket Club (MCC) in 1947, when he was also elected Honorary Life Member. Founded in 1787, the MCC is the owner of Lord's Cricket Ground and the guardian of the laws of the game. When he was elected to serve a second term as President in 1974, Prince Philip was one of only three people to serve two terms. One of his final engagements in May 2017 was to open the new Warner Stand, when he wore his 'egg and bacon' club tie in the colours yellow and red.

Prince Philip was also Patron and Twelfth Man of the Lord's Taverners, positions he held from the formation of the club in 1950. This is the leading cricket charity for young people and those with disabilities, holding regular celebrity matches to raise funds.

The Olympic Games and the Commonwealth Games

Prince Philip had a long-standing interest in the Olympic Games. He first visited the Olympics when they were held in Helsinki in 1952, where he watched several events. In 1956 the Prince opened the Olympic Games in Melbourne on behalf of The Queen; the Melbourne Cricket Ground was packed with 100,000 spectators for the opening ceremony of the first Olympics in the southern hemisphere. He arranged a few days without official engagements so that he could attend some of the events.

Prince Philip inspects an Australian army guard of honour as he opens the Commonwealth Games in Brisbane, Australia, 1982

Prince Philip took a keen interest in the preparations for the 2012 Olympic and Paralympic Games. On a visit to the site in East London in 2010, Lord Coe, Chairman of London 2012 and a former Olympic athlete, commented that the Prince 'has a very broad understanding of sport and the nature and complexity of putting an Olympic Games together'.

Prince Philip first visited the Commonwealth Games in 1954 in Vancouver when he performed the official closing ceremony. This was the beginning of a long relationship between Prince Philip and the Games. He became President of the Commonwealth Games Federation the following year, in 1955, and continued in that role for 59 years, handing over to The Earl of Wessex, who succeeded him at the Commonwealth Games held in Glasgow in 2014.

LEFT: Prince Philip meets Team GB athletes at the Olympic Village during the Olympic Games in London, 2012

RIGHT: Tie in the colours of the Olympic rings presented to Prince Philip during the Olympic Games in Montreal, 1976

SUPPORTING THE
ARMED FORCES

P RINCE PHILIP'S first public speech was made in the
summer of 1947, when he unveiled the Second World War
memorial at Corsham, Wiltshire, where he had been posted
as a naval instructor. He was created an Admiral of the Fleet
on The Queen's accession. The First Lord of the Admiralty
called this promotion 'popular' among the force following the
Prince's naval service between 1939 and 1951. Prince Philip's
engagements in support of the Royal Navy included Fleet
Reviews, the laying of the keel of the United Kingdom's first
nuclear submarine HMS *Dreadnought* at Barrow-in-Furness
in 1959, and attending the launch of the aircraft carrier HMS
Queen Elizabeth, the Royal Navy's largest ship, at Rosyth in 2014.

On The Queen's accession, Prince Philip was also created
a Field Marshal in the British Army and an Air Marshal of the
Royal Air Force (RAF). The Prince wore the uniform of a Field
Marshal for the first time at The Queen's Birthday Parade in
1953, the first of the new reign.

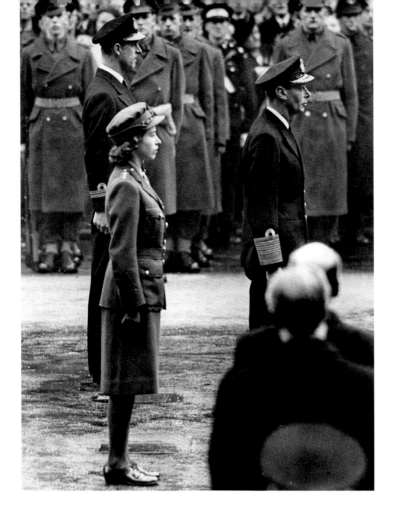

On Remembrance Sunday 1947, just 11 days before their wedding, Prince Philip and Princess Elizabeth joined her father King George VI at the first post-war Remembrance Service to be held at the Cenotaph in Whitehall

At the annual Queen's Birthday Parade, also known as Trooping the Colour, Prince Philip would accompany The Queen in her inspection of the troops, riding on horseback and joining other members of the Royal Family on the Buckingham Palace balcony afterwards for the RAF fly-past. In 2002, at the age of 81, he gave up riding in the procession, thereafter joining The Queen in her carriage. He last attended the parade in 2017, a few months before his retirement.

Prince Philip and Burma Star
Association veterans, 1986

In 1954 Prince Philip became Colonel of the Regiment for
the Welsh Guards and carried out his first army inspection of
the 4th Battalion at Caterham that year. The same year he was
also invited to become Captain General of the Royal Marines,
the regiment's Commandant General having expressed the
corps' particular wish to have the Prince as its chief officer.

In 1956 Prince Philip became Colonel-in-Chief of the
Wiltshire Regiment (Duke of Edinburgh's), now part of
The Rifles. In 2020 at Windsor Castle he handed over the

appointment to The Duchess of Cornwall during a socially distanced ceremony broadcast to The Duchess's home at Highgrove House in Gloucestershire.

A significant part of Prince Philip's official duties were in support of veterans. In 1960 he became Patron of the Guinea Pig Club on the death of its founder, the surgeon Sir Archibald McIndoe, renowned for his work with service personnel at the burns unit of the Queen Victoria Hospital, East Grinstead.

Prince Philip attended the annual Remembrance Service at the Cenotaph in Whitehall between 1947 and 2017, laying his own wreath, directly following The Queen. In 2011, to mark his 90th birthday, The Queen granted Prince Philip the title of Lord High Admiral, the titular head of the Royal Navy and the culmination of a lifetime of seamanship and support for maritime occupations.

TOP: Prince Philip is briefed before entering the sterile burns unit, Queen Victoria Hospital, East Grinstead, 1965. In 1960 Prince Philip had been made Patron of the Guinea Pig Club, the name by which patients at the pioneering burns unit were informally known

ABOVE: The Queen and Prince Philip at The Queen's Birthday Parade, 2016. Between 2002 and his retirement in 2017, the Prince travelled with Her Majesty in a horse-drawn phaeton made for Queen Victoria in 1842

ART AND
COLLECTING

IN 1994, PRINCE PHILIP wrote: 'I find it difficult to go into a room without looking carefully at every picture in it'. He was an avid collector and a talented artist.

Princess Elizabeth and Prince Philip were given a number of works by twentieth-century artists on the occasion of their marriage. Many other paintings were acquired for particular residences. When the couple moved into Clarence House in 1949, they decided they would like works by contemporary artists to hang on the walls of their own rooms.

Prince Philip became interested in the work of one of Britain's leading artists, Graham Sutherland, and acquired his painting *Armillary Sphere* in 1957. The Queen and Prince Philip later purchased a study for Sutherland's tapestry for the new Coventry Cathedral, *Christ in Glory in the Tetramorph*.

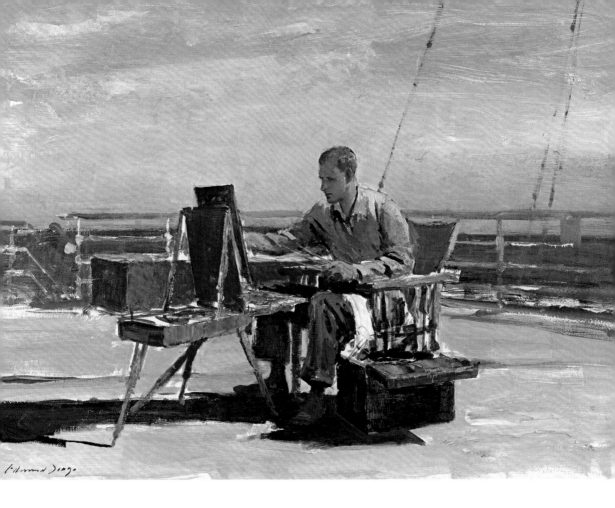

Prince Philip much admired the work of Norfolk-born artist Edward Seago, who was also a favourite of both King George VI and Queen Elizabeth. The Prince had met Seago on several occasions at Sandringham and in 1956 he invited the artist to join him on board HMY *Britannia* in Melbourne as she sailed through Antarctica and the South Atlantic on her return to Britain. Seago, who was probably the first professional artist to record Antarctica, was captivated by the 'space, loneliness and

Edward Seago, *Prince Philip Painting on the Deck of HMY 'Britannia'*, 1957. Prince Philip enjoyed watching Seago at work on board HMY *Britannia* as she sailed through Antarctica and often joined him to work on his own paintings. Here, Seago recorded the Prince painting on deck

Paul Nash, *Tamaris Well*, 1930–2, a wedding gift from the Guild of Air Pilots and Air Navigators, which Prince Philip and Princess Elizabeth hung in their new London home, Clarence House

greatness' of the magnificent scenery. He was a major influence on the Prince's own painting style. He wrote a list of colours required for a palette, which the Prince kept in the back of his paintbox. Seago acted as an artistic mentor to Prince Philip until his death in 1974.

Between 1958 and 1996, Prince Philip acquired a large number of works by contemporary Scottish artists from the annual exhibitions of the Royal Scottish Academy (RSA) in Edinburgh. These were intended primarily to hang on the walls of the private apartments of the Palace of Holyroodhouse, The Queen's official residence in Scotland. The first purchase by the Prince, in 1958, was of 14 paintings. Prince Philip received the highest compliment from the RSA when he was offered Honorary Membership in 1963.

Edward Seago, *Icebergs near Base 'W',
Grahamland*, 1957. Prince Philip wrote of
the artist: 'We could hardly tear him away
from his easel to come to meals. He was
fascinated by the icebergs, the colour
of the sea between the drifting pack-ice
and the background of glaciers and
snow-covered hills ... We were fascinated
by his almost miraculous technique'

Robin Philipson, *Cock and Hen*, 1953–8, one of the first paintings purchased by Prince Philip from the Royal Scottish Academy. Philipson, a lecturer at Edinburgh College of Art, later became President of the Royal Scottish Academy

For the next 30 or more years Prince Philip visited the RSA regularly and purchased a few pieces each time. He wrote: 'I had no set plan except perhaps I tended to avoid the more "avant-garde" type of picture ... I thought they might look a bit unhappy in their surroundings'. In 1987 the Prince agreed to lend a number of works to an exhibition organised by the Friends of the RSA, of which he was Patron. Future acquisitions were mainly for Holyroodhouse but also included some destined for Balmoral and Buckingham Palace. Purchases often reflected the Prince's interests in Scottish landscapes and wildlife, as well as natural history and the environment.

An enthusiasm for paintings by Australian artists began during Prince Philip's visits to the country. He met the acclaimed artist Sidney Nolan when he opened one of his exhibitions in Perth in 1962, and was presented with *Strange Fruit*. Prince Philip and The Queen had previously purchased *Utah* by the artist in 1960.

Cartoons and caricatures were a favourite of the Prince, and over the years he built up a sizeable collection. The subject matter often reflected Prince Philip's particular interests as well as depicting the Prince himself. He served as Patron of the Cartoon Museum from 1994.

Prince Philip was a gifted amateur painter, a talent he may well have inherited from his father, Prince Andrew, who was an accomplished watercolour artist. His maternal grandfather, Prince Louis of Battenberg, was a proficient draughtsman who

James Orr, *Morning Light, Banffshire*, 1979–84, purchased from the RSA by Prince Philip, reflecting his interest in Scottish landscapes

Sidney Nolan, *Herd at the Waterhole*, 1963, purchased by The Queen for Prince Philip in 1963, to add to their collection of works by the artist

provided drawings for *The Illustrated London News* of the future King Edward VII's tour of India in 1875–6. It was the artist Denys Dawnay who, shortly after Prince Philip's marriage, suggested he take up painting and gave him his first paintbox and easel.

Prince Philip worked mainly in oils and handled the paint with confidence and skill. He tended to favour landscape

subjects but also painted the occasional figure study, such as his painting of *HM The Queen Reading in the Private Dining Room, Windsor* (see overleaf). He was equally inspired by the landscapes in Norfolk, around Sandringham, the Scottish Highlands surrounding Balmoral and the environs of Windsor Castle.

Carl Giles, *What's the betting whoever organised this match is sitting in front of a nice big fire at Sandringham?*, 1952. Prince Philip acquired this cartoon of a lively cricket match between Guards and children in front of Buckingham Palace

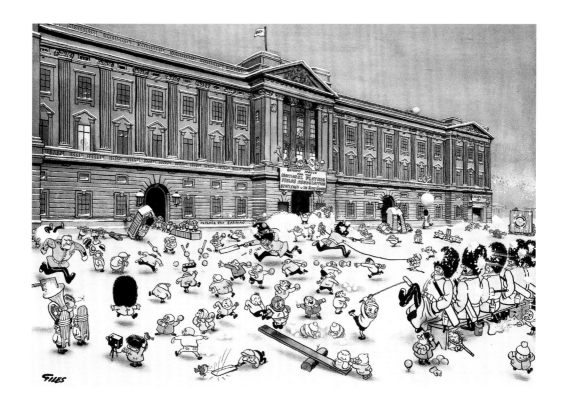

Prince Philip, *HM The Queen Reading in
the Private Dining Room, Windsor*, 1965

Prince Philip's oil painting
of trees at Balmoral, c.1985

LEGACY

IN A SPONTANEOUS DISPLAY of affection and gratitude, thousands of people came to Buckingham Palace and Windsor Castle to offer floral tributes to The Duke of Edinburgh after his death was announced on 9 April 2021. The Duke, who had wanted 'no fuss', would have been genuinely surprised to know how many people, of all ages and nations, held him in such high regard.

They did so for many reasons. Some remembered him as the handsome naval officer who captured the heart of the young Princess Elizabeth and who quietly but effectively performed the role of consort throughout many decades. Others remembered him as the family man who relished the time he spent with his own children and then with grandchildren and great-grandchildren in later life and whose determination to help young people develop their full potential was marked by his establishment of the Duke of Edinburgh's Award.

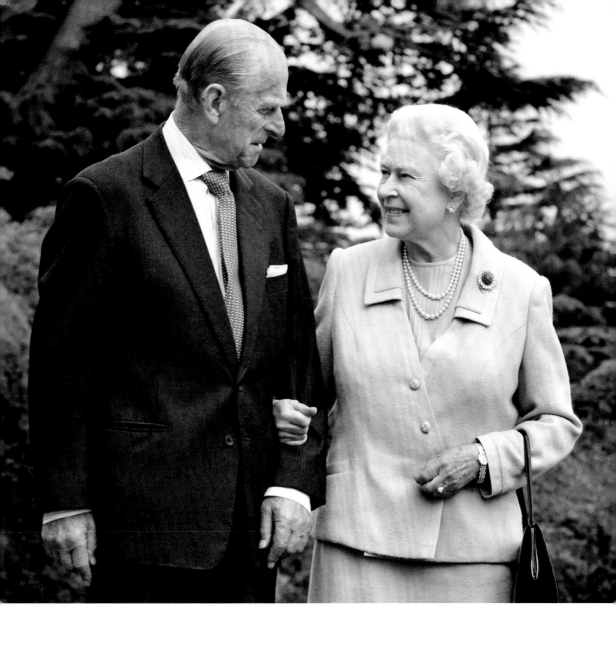

Prince Philip and The Queen photographed
at Broadlands, Hampshire, to mark their
Diamond Wedding anniversary, 2007

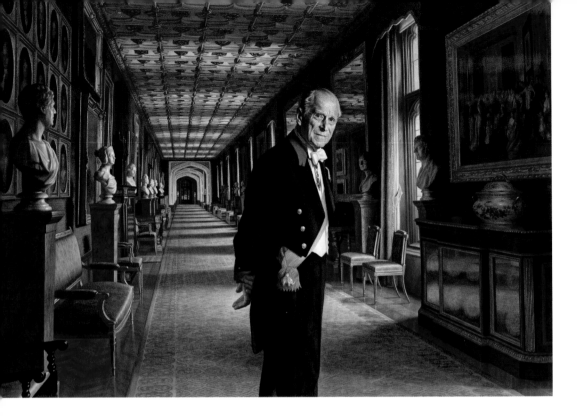

Painted in 2017, Ralph Heimans'
portrait of Prince Philip
celebrates his antecedents.
He wears the sash and badge
of Denmark's highest chivalric
honour, the Order of the
Elephant, reminding us that
his great-grandfather was
Christian IX of Denmark.
The painting on the wall to the
right depicts Queen Victoria,
his great-great-grandmother,
along with his grandmother and
mother. He is standing in the
Grand Corridor at Windsor Castle,
not far from the room where
his mother was born in 1885

Some celebrated him as a knowledgeable and committed
conservation pioneer, who helped to found the World Wildlife
Fund for Nature (WWF) in 1961 and who called upon heads of
state and faith leaders around the world to treasure the planet
and work for environmental sustainability.

In a rounded life in which there never seemed to be an
idle moment, he proved to be an able artist, architect and
designer – taking charge of the post-fire restoration of Windsor
Castle – and a sportsman competing in carriage-driving at
an international level, talents that he encouraged in others,
including his own children.

His respect for the skill of contemporary artists – such as
Edward Seago, Barbara Hepworth, Sidney Nolan and Lucie Rie

– and the pleasure he took in collecting political cartoons was matched by admiration for the ingenuity of the scientist and engineer – a subject on which he spoke on many occasions in support of technology, research and industry.

It was characteristic of all his work – his public duties and his private interests – that he did nothing half-heartedly. He set an example to us all by approaching life as an adventure and, as the pages of this book amply demonstrate, he made a positive mark upon the world, leaving it a much better place.

An inspection of the Royal Marines on 2 August 2017, carried out in heavy rain on the forecourt of Buckingham Palace, marked the last official solo engagement for Prince Philip. In response to a rousing three cheers, their Captain General raised his bowler hat

ABOVE: His Royal Highness The Prince Philip, Duke of Edinburgh retired from solo public engagements at the age of 96 on 2 August 2017. During a lifetime of public service, he carried out 22,234 solo engagements, made 637 solo overseas visits to 143 different countries, chaired 1,638 meetings, gave 5,496 speeches and wrote 14 books. His diverse interests and patronages were always reflected in the work he undertook in support of The Queen.

OPPOSITE: Her Majesty The Queen announced that her beloved husband, Prince Philip, had died peacefully at Windsor Castle on 9 April 2021. This private photograph taken by The Countess of Wessex shows The Queen and Prince Philip enjoying the view at the top of the Coyles of Muick, in the Scottish Highlands near Balmoral Castle, in 2003.

'My dear Papa was a very special person.'
The words of The Prince of Wales paying
tribute to his father's lifetime achievements.

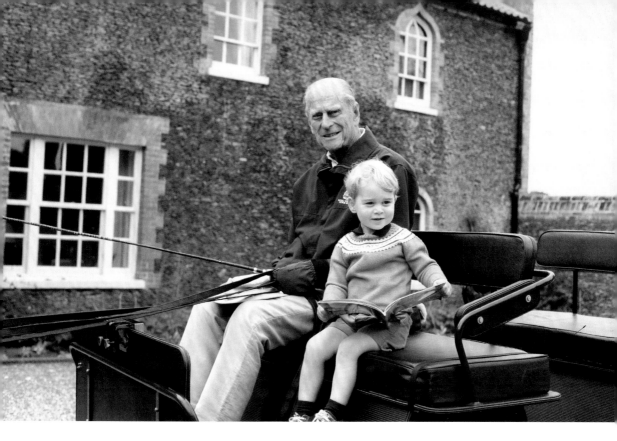

'My grandfather's century of life was defined
by service – to his country and Commonwealth,
to his wife and Queen, and to our family.'
The words of The Duke of Cambridge, whose
son Prince George is seen here with his great-
grandfather in Norfolk, in a photograph taken
by The Duchess of Cambridge in 2015 when
Prince George was two years of age.

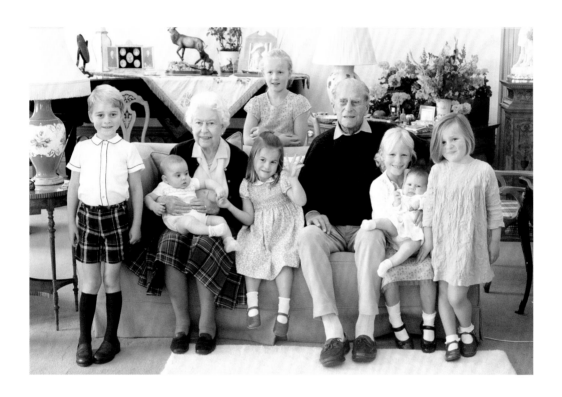

The Queen and Prince Philip photographed by
The Duchess of Cambridge at Balmoral Castle,
enjoying a family gathering with all seven of their
great-grandchildren, in 2018. From left to right:
Prince George, Prince Louis, Princess Charlotte,
Savannah Phillips (standing), Isla Phillips, Lena
Tindall and Mia Tindall.

The funeral of The Duke of Edinburgh took place in St George's Chapel, Windsor Castle, on 17 April 2021. The service was a family occasion which included some unique personal touches in line with his wishes. The Duke's coffin was carried to the Chapel in a modified Land Rover that he had helped to design and that reflected his love of the outdoors.

His personal Standard was draped over the coffin, with each of the four quarters representing an aspect of his lineage: lions and hearts for Denmark, a white cross on blue background for Greece, two black 'pales' (vertical stripes) on a white background from the Mountbatten coat of arms, and a representation of Edinburgh Castle based on the Scottish capital's coat of arms.

ACKNOWLEDGEMENTS

Many generous colleagues have contributed to the compilation of this publication. For their help and guidance we wish to thank Archie Miller-Bakewell, Alexandra McCreery, Suzy Lethbridge, Kate Gillham and Danielle Metcalfe from the Royal Household. We are also grateful for the assistance of the following colleagues from Royal Collection Trust: Tamsin Douglas, Ellie Gray, Caroline de Guitaut, Kate Heard, Kathryn Jones, Karen Lawson, Alessandro Nasini, Daniel Partridge, Rachel Sharples, Desmond Shawe-Taylor, Elizabeth Silverton, Emma Stuart, Emma Thompson, Hannah Walton and Sophy Wills. We would like to express further gratitude to the following: Sir Marcus O'Lone, Paul Sedgwick, Ruth Hackney and Natalie Russell of the Crown Estate; Charlotte Manley, Gary McKeone and Kate McQuillian at St George's Chapel, Windsor Castle; Judith Radcliffe from Britten Pears Arts; Carol Morgan from the Institute of Civil Engineers; Chris Aitken from the Prince Philip Trust Fund; Chris Kennedy from the Royal Microscopical Society; and Sandy Wood and Robin Rodger from the Royal Scottish Academy. Lastly, we owe thanks to Adrian Hunt and the Publishing team of Polly Atkinson and Kate Owen.

Published 2021 by Royal Collection Trust
York House
St James's Palace
London SW1A 1BQ

Royal Collection Trust /
© Her Majesty Queen Elizabeth II 2021

ISBN 978 1 909741 80 5

102498

British Library Cataloguing-in-Publication Data:
A catalogue record of this book is available from the
British Library.

Edited by Linda Schofield
Designed by Adrian Hunt
Project Editor: Polly Atkinson
Production Manager: Sarah Tucker
Colour reproduction by Altaimage
Typeset in Freight
Printed on 150gsm Claro silk
Printed and bound in Wales by Gomer Press

FRONT COVER: Prince Philip doffs his top hat during
the opening ceremony of the World Carriage Driving
Championships, Windsor, 1980

BACK COVER: The Queen and Prince Philip
on the balcony at Buckingham Palace after
the Coronation, 2 June 1953

FRONTISPIECE: Prince Philip, painted by
Ralph Heimans in 2017

FACING CONTENTS PAGE:
David Poole, *HRH The Duke of Edinburgh*, 1986

PAGE 6: Father and son photographed on board
HMS *Bronington* on 20 February 1976. Prince Charles
had taken command of the minehunter just 11 days
previously, on 9 February, and Prince Philip paid a
visit in his capacity as Admiral of the Fleet

PAGE 138: Prince Philip, photographed by Terry O'Neill,
on the Grand Corridor at Windsor Castle, 1992

MIX
Paper from
responsible sources
FSC® C114687
FSC
www.fsc.org